HAVERHILL
THROUGH TIME

Roy Brazier

AMBERLEY PUBLISHING

First published 2009

Amberley Publishing Plc
Cirencester Road, Chalford,
Stroud, Gloucestershire, GL6 8PE

www.amberley-books.com

British Library Cataloguing in Publication Data.
A catalogue record for this book is available from the British Library.

ISBN 978 1 84868 795 0

Typesetting and Origination by Amberley Publishing.
Printed in Great Britain.

Acknowledgements

Most of the old photographs come from the files of the Haverhill and District Local History Group, with additional images from Dennis Backler. Thanks go to the group's secretary, Tony Turner, for providing the modern photographs, which were taken in mostly the same positions as the older ones. For this he scaled the church tower and the top of the old Corn Exchange, and sometimes stood in the middle of a busy new road which was not there when the original photograph was taken. Marty House proofread the finished text, and other members of the history group had their say and opinions as to whether the locations as we found them were the same.

Introduction

In the mid-1950s, Haverhill was described thus, 'The ancient market town of Haverhill stands at the head of a picturesque valley, and approached from the east the town is seen nestling in a quiet dip in the rolling hills of East Anglia.' Arable farming was the principal industry for this part of England, and in the summertime, when the corn was ripe, the seemingly endless golden fields stretching into the distance were a picture not to be forgotten. Haverhill was for countless years a small market town, quiet and unassuming, within easy distance of a number of other East Anglian towns, Cambridge being twenty miles away, and Bury St Edmunds and Sudbury both eighteen miles. London was also well within reach of the townspeople over sixty years ago, travelling by coach or the numerous trains.

Standing, as it does, close to the county borders of Cambridgeshire and Essex, the west Suffolk town of Haverhill has probably changed more over the last few decades than any other town of its size in Great Britain. While Haverhill underwent significant change in the Victorian era when numerous buildings were put up, the photographs in this book show the further change of the last fifty years. Fewer Victorian buildings remain now, as older structures were ruthlessly demolished in the name of progress.

From a small country town with a weekly cattle and livestock market, Haverhill's population vastly increased after the town was selected as an overspill for London. (Some people started to call Haverhill a 'new town', but this is not the case.) In 1951 the population count stood at 4,230, but has now increased to over 22,000. More houses were needed for the growing population. Between the end of the Second World War in 1945 and 1949, nearly sixty new dwellings were built by the local council; altogether there were 260 houses owned by the Urban District Council at that time. Haverhill began to expand its council housing estates and by 1970 there were 2,630 council houses. The Parkway was the first, followed by the Clements and Chalkstone Estates. Soon the town was spreading out of the valley, surrounding the town centre by more and more housing, now catering more for homeowners than tenants.

Numerous businesses relocated to the town and provided jobs for

the newcomers. From having very few factories, there are now a vast array of industries in modern Haverhill.

For many years the main A604 Cambridge to Harwich road ran right through the middle of the town, but in 1960 a small relief road was built, cutting its way through the picturesque meadows of Haverhill. In 1996, after several false starts, a southern by-pass was built, and now a northern by-pass is in the pipeline. Some things are mourned at their passing, including the two railway stations in the town; Haverhill now has no railway connection with the outside world.

The unobtrusive Stour Brook which flows through the town was at one time unpredictable, resulting in disastrous floods in 1958 and 1968. A flood park constructed at the west of the town, together with the straightening of the river at some places through the town, has solved this problem.

Although many of the attractive old buildings which made the town a pleasant place to live have been reduced to rubble, perhaps one of the better changes in Haverhill was the clearing of Peas Hill. The old houses were demolished, completely sweeping away the cluttered centre of the town. This has opened up the middle of the town with a new Market Square. The Friday market is held there, and, in the summer, the square is a centre for outdoor concerts and other entertainment.

Some parts of the town are virtually unrecognisable now, and sometimes one has to look hard to see evidence of what was there before. From a small town where nearly everyone recognised everyone else when shopping, Haverhill has caught up with most other towns, and a multi-cultural diversity of residents is obvious in modern Haverhill. While some older residents often long for the good old times with small family shops, others think the time has come for Haverhill to accept that it is now well into the world of today.

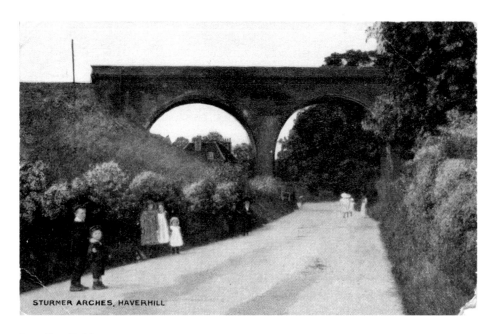

STURMER ARCHES, HAVERHILL

Junction Bridge

Commonly known as Sturmer Arches, built in 1865 to link the Colne Valley Railway and Haverhill South Station to the Great Eastern Railway and Haverhill North Station. The embankment on either side was built up with earth from cuttings made on the railway. The bridge is still in position in the present day. When it was announced that the bridge was to be demolished, a petition was presented to the authorities, and 'The Gateway' into Haverhill was saved.

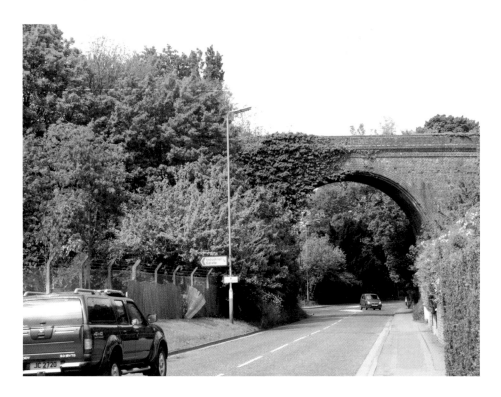

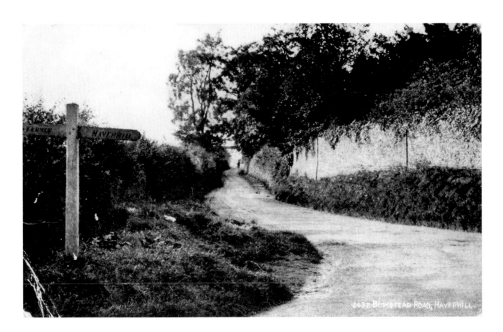

Bumpstead Road

This was just an old country lane leading to the twin villages of Steeple and Helions Bumpstead in the 1880s. The road was also part of the stagecoach route from the Bell Hotel in Haverhill to London in the early nineteenth century. It is now one of the busier roads in Haverhill, leading to the main industrial estate. In the wall on the right, obscured by shrubbery, a slab in the wall bears the date 1795. This could be the date that Vale Place House was built.

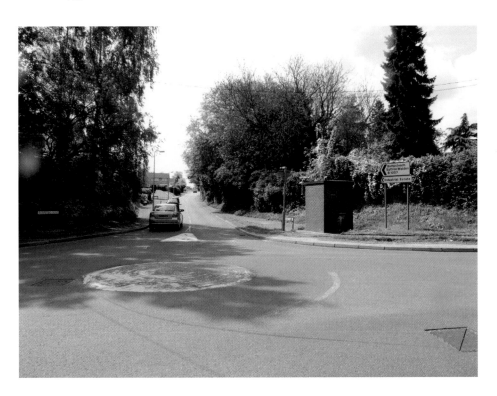

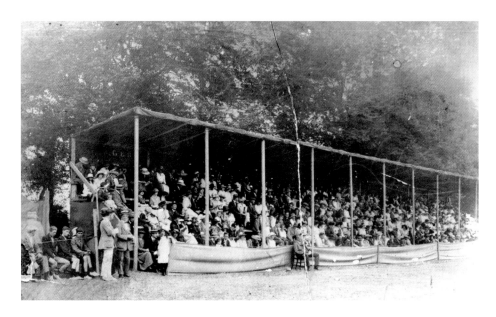

Hamlet Croft

The home of Haverhill Rovers Football Club did not have a permanent grandstand in the early years. Instead, a temporary structure, such as this one shown in 1912, was erected each year for the Haverhill Gala and other special events. The grandstand at the present time was built at a cost of £300, and opened in 1935 by Mr Bennett Whiting. This money had been raised in under a year by a '5,000 shilling fund', overseen by the Haverhill Helpers Committee.

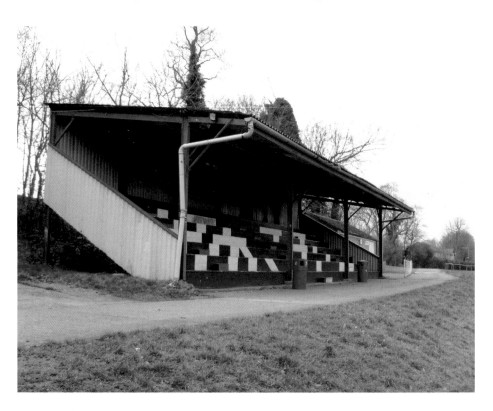

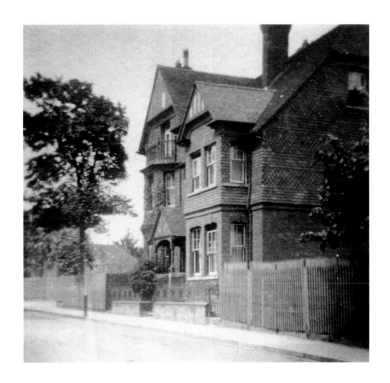

Hamlet Road

Elmhurst was one of Haverhill's most attractive houses standing in Hamlet Road, with extensive gardens. One of the early residents was Mr W. Bigmore, a silk weaver, as were most of his neighbours, a silk factory being just down the road. The house, demolished in 1960, has made way for a private housing development named Elmhurst Close. The original house stood where the 'Sold' notice is seen.

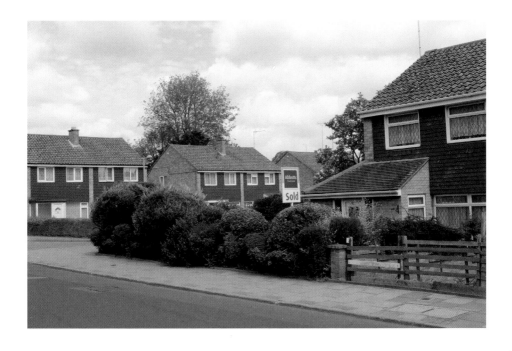

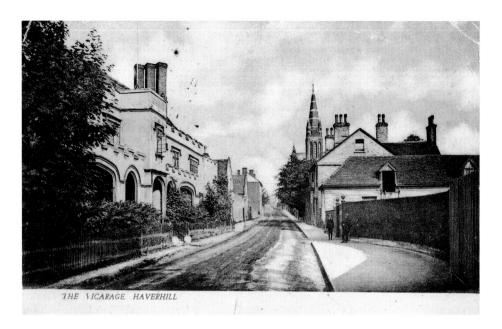

THE VICARAGE. HAVERHILL

Hamlet Road

Looking towards the town centre. The old vicarage, dating from the seventeenth century, had a stuccoed and castellated veranda and porch added in the nineteenth century. On the right, two boys are standing by the curved fence where the road widened to allow a coach and horses to turn. The false front of Cleves House was removed in 1974, revealing its original half-timbered front, and it is now one of the most attractive buildings in the town. When records were wrongly interpreted, the old vicarage was misnamed 'Cleves House'.

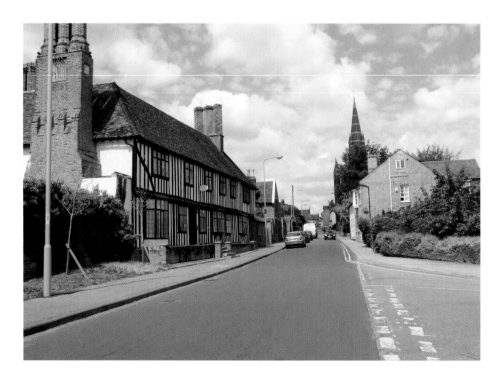

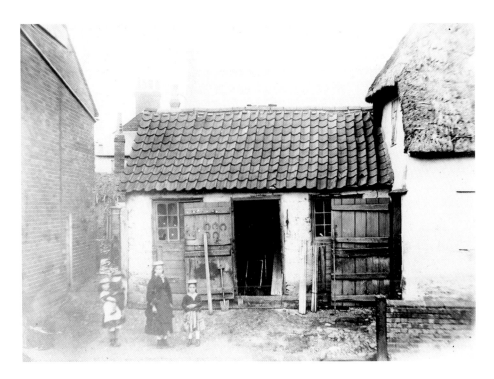

Blacksmith's Shop

This establishment in Hamlet Road, close to the Old Independent Church, was one of several blacksmiths in Haverhill, *c.* 1880. At one time the hamlet was said to have one-fifth of the population of the whole town. The old blacksmith's shop premises survived into the early 1900s. The building on the left was at one time a small shop, with Turners Yard at the rear. It is now a private house once again.

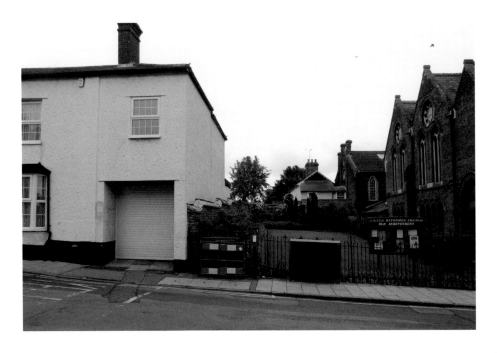

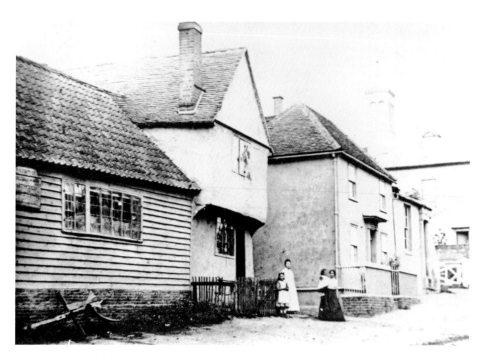

The Weavers

Undoubtedly one of the oldest houses in Haverhill, dating from the medieval period. The open hall was to the left, and the Weavers Arms public house also stood next door to the left. The Weavers housed one of the first schools in the town, known as the Jubilee School, in 1812. The Weavers was bought by Mr Daniel Maynard Gurteen in the 1930s, and Miss Grace Gurteen moved into the house in 1952. It is no longer a private house, but converted to offices.

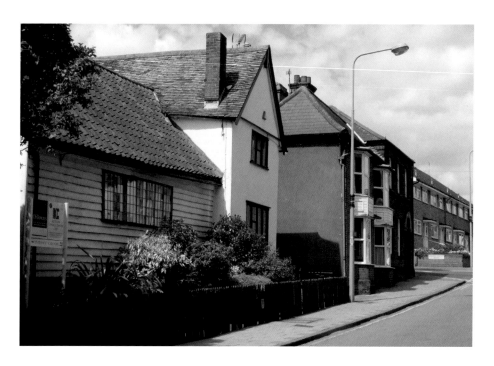

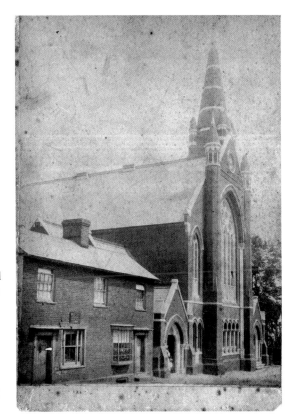

Hamlet Road

Looking east from the top of the High Street, near the old border of Essex and Suffolk. Although the road looks like a minor roadway, this was the main Cambridge to Colchester road, turnpiked in 1766. Today's view is now all Suffolk as the Essex boundary has been changed over the intervening years. The area is landscaped into a neat lawn and flower garden, brightening this small part of Haverhill.

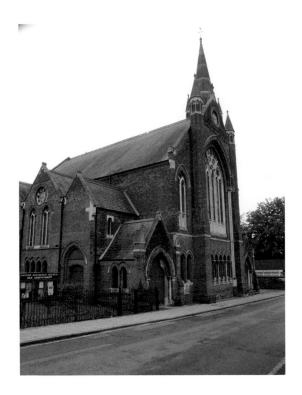

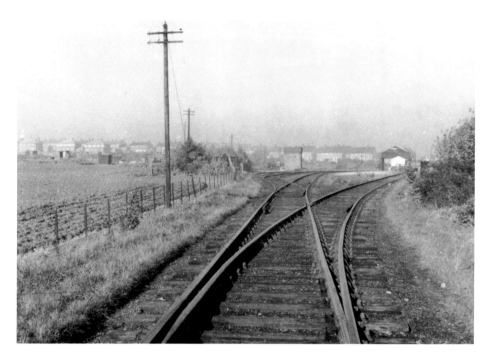

Haverhill South Railway Station

This was the terminus for the Colne Valley Railway, opened in 1863 and closed to passengers in 1923. In the background can be seen new houses in Duddery Hill. The sidings are on the left and the goods shed on the right. Although the track bed can still be traced, the station with its attendant buildings has disappeared altogether. In their place is a group of new houses, which could have been named Station Close.

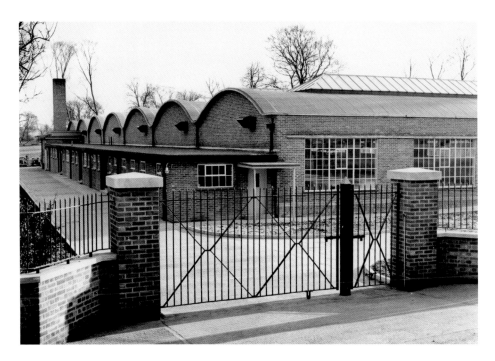

PYE Telecommunications

This firm came to Haverhill in 1954, and moved to this factory in Colne Valley Road three years later. Many government contracts were filled here, including the link to the USA from Goonhilly Downs, Cornwall, once the largest satellite earth station. After nearly thirty years of working in Haverhill, the firm centralised all its production in Cambridge. It had also been taken over by the Philips Group of Holland, putting most of its local labour force out of work. The factory was finally demolished.

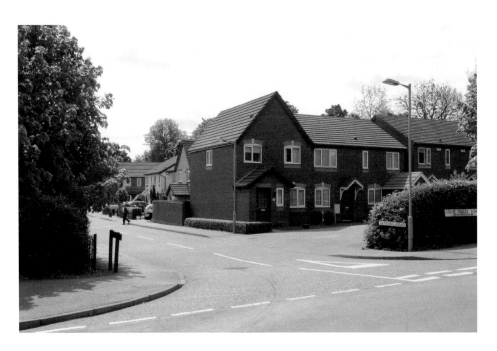

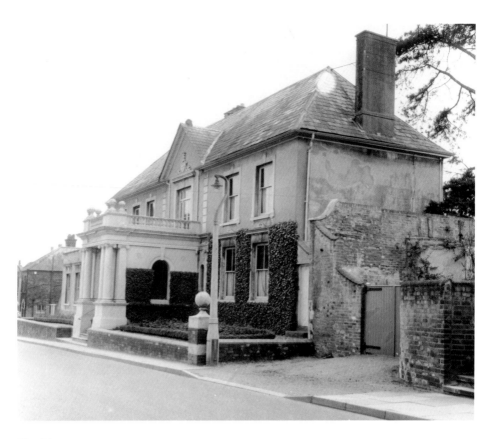

The Mount

This was one of the largest houses in Haverhill, and many still mourn its passing into history. In 1893, it became the home of Mr Daniel Maynard Gurteen. In the rambling house, the fine staircase was said to come from Horseheath Hall when it was demolished in the eighteenth century. This most interesting house has completely disappeared from the top part of the High Street, a terrace of more modern housing occupying the spot where it once stood.

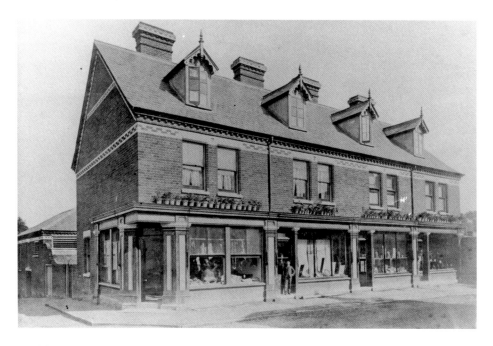

Duddery Terrace

This is known to most townsfolk as just part of the High Street. It was, however, built in 1878 by Daniel Gurteen Jnr on part of the gardens which stood opposite the Mount. As the millennium came and went, these shops and the accommodation above were destined to be turned into more flats, but this plan was changed and the shops have been returned to retail use. The terrace has now been sympathetically restored to close to its original condition.

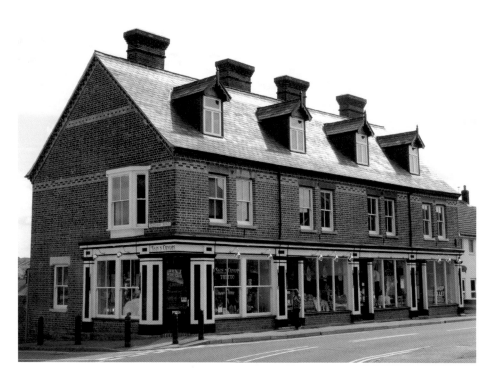

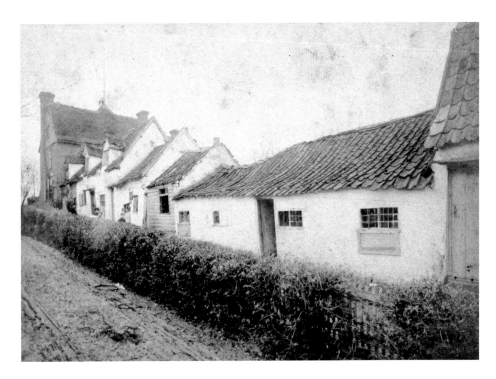

Old Cottages

These cottages stood in Duddery Hill, originally known as Duddery Lane. They were just behind the White Hart public house. The photo dates from *c.* 1880, and shows the very muddy and uneven state of the road. Duddery Hill is now part of the new roads around the town centre and is on the route of the town's bus service. The old White Hart was demolished and the road re-aligned.

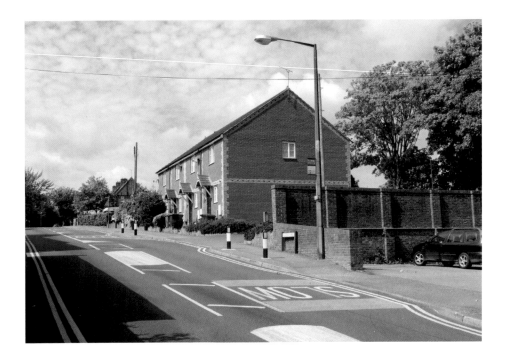

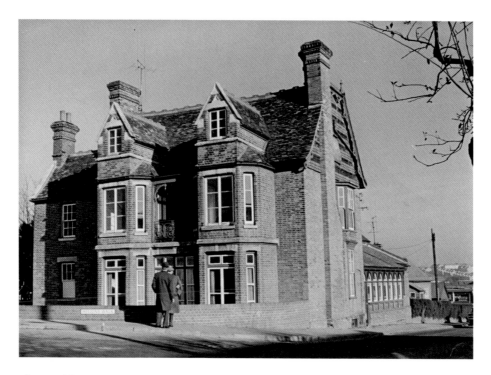

The Duddery

The name is derived from 'duds', the slang word for clothes. The house belonged to the Lord of the Manor in 1851, and was occupied at the time by Mr William Basham. Daniel Gurteen Jnr bought the Duddery in 1869. The Duddery was yet another grand old house of Haverhill which was demolished. It had an impressive conservatory built on one end where some wonderful parties and music concerts were held. Now in its place are just a few parking spaces.

The White Hart

The old building stood on one of the narrowest parts of the High Street. It is thought the road was deliberately narrow to make it easy to collect the dues for the ancient market as people came into town. The modern-day picture shows a completely new public house, built much further back from the once dangerous corner. It has an outside gallery for use in the summertime, and sports fans are enticed inside to watch televised events on the big screen.

High Street

At the top end of the High Street, again showing how narrow the roadway was. Double-yellow lines have already been painted to stop motorists making it more so. Also narrow are the pavements on either side. Removing the old public house now lets the light in, and also widens the High Street. On the left, the small row of shops and a taxi office still have a narrow pavement.

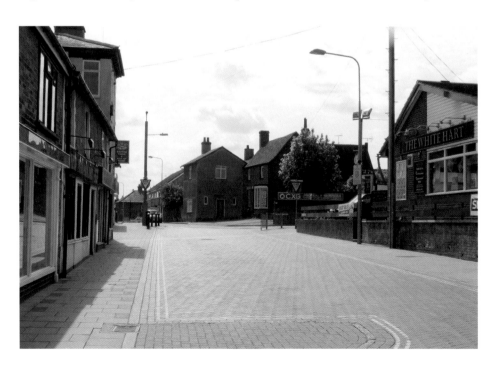

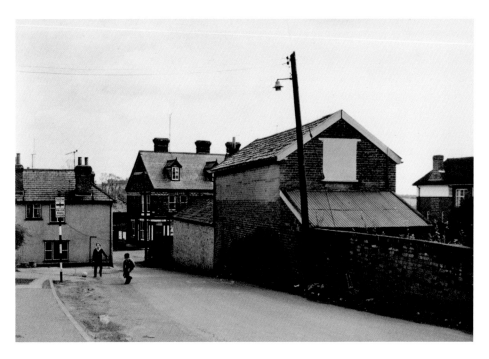

High Street Junction

The view from the rear emphasises how poor the junction of Duddery Hill and the High Street was. The two boys are taking advantage of the nearly traffic-free road for an improvised football pitch, but should be aware of the cellar doors of the White Hart. Although the High Street turning is now wider, the one-way system in the street means there is no turning left on to it. Opposite is Duddery Road.

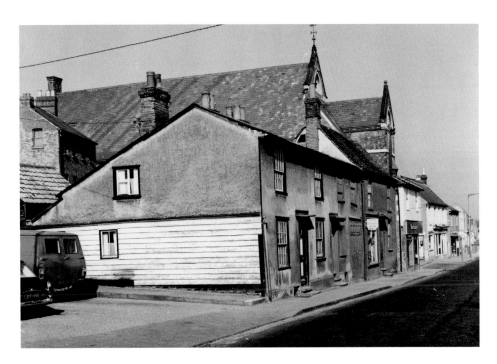

High Street

Looking westerly *c.* 1960. In the foreground is a very small car park which was overlooked by a pair of thatched cottages. Public tennis courts, opened in 1939, stood behind the cottages. In the modern scene the little car park has been swallowed up, but a path leads to a large modern car park. There is now an amusement arcade, a fast food take-away and offices of a local solicitors firm. Next to the Town Hall is a hairdressing salon.

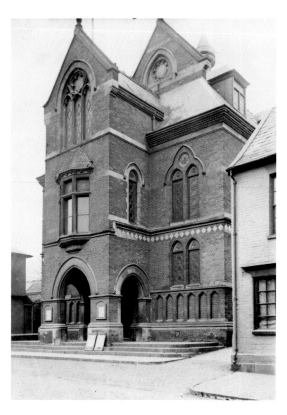

Town Hall

Standing back slightly from the line of the High Street, this Victorian building towers above the surrounding buildings. It was built in 1883, costing £5,000, and was presented to the town by Daniel Gurteen Snr in celebration of his golden wedding anniversary. Today the outside of the building looks much the same. The interior is much changed after refurbishment, and the building is now called the Haverhill Arts Centre, with a bistro area, Town Council offices, and a local history centre. Live theatre and cinema are now the attractions.

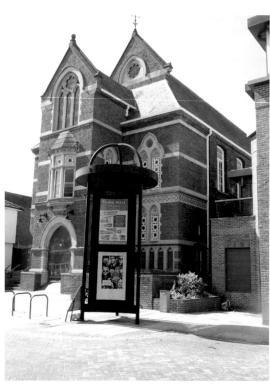

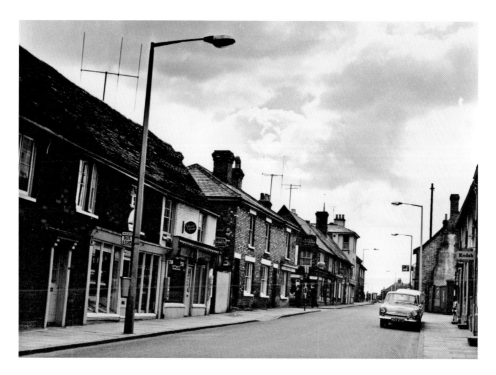

High Street

Looking east in the late 1950s. Behind the street lamp on the left is the shop of E.J. Farrant, fruit and vegetable merchant. Next is H.B. Shanks; then the Royal Exchange public house next to Eden Road, whose houses were built in 1871 for Gurteen factory workers. In an up-to-date view of the area The Royal Exchange is in the same place, but the old shops are now replaced by a line of new shops with flats above called Heron House.

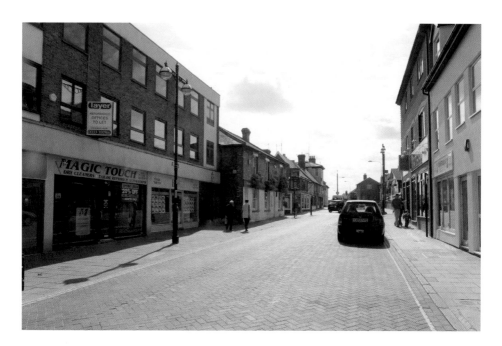

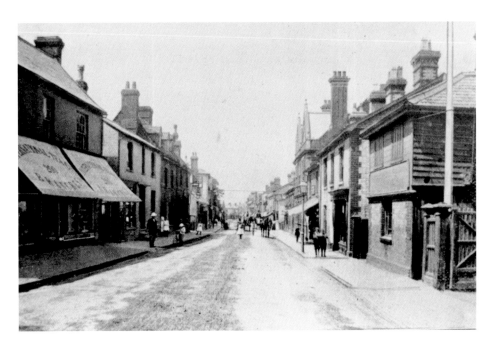

High Street

Taken in front of the Town Hall, *c.* 1900. At the extreme right is the entrance to the yard of Mason & Sons. The firm constructed notable buildings in Victorian Haverhill, and, at its peak, employed 102 men and 16 boys. The double-fronted shop on the left is the International Tea Company. Modern buildings now occupy the High Street. Here is the other part of Heron House and line of shops on the site of Mason's yards and Cambridge House.

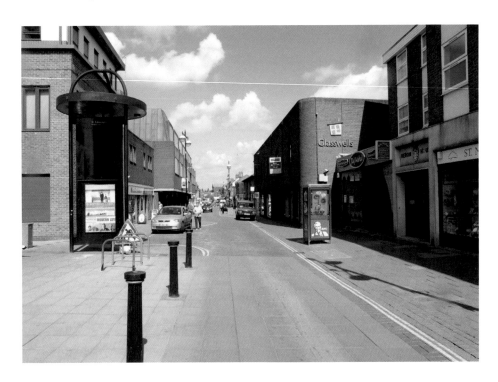

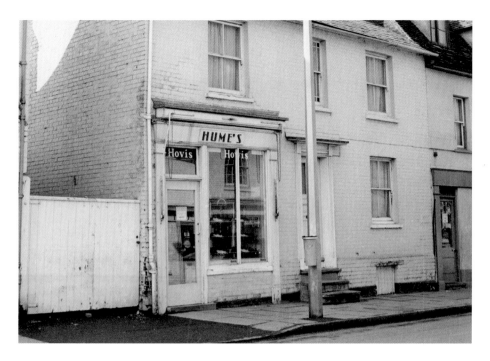

High Street

Haverhill consisted mainly of family-owned shops, of which Hume's at number forty was one. It was a bakers and confectioner owned earlier by the Pannells, then the Earl Brothers. The shop on the right is Copsey's, whose fish and chips were thought to be the best in town. The small family shop has been demolished together with the surrounding buildings, and number forty is now Henderson's, one of a chain of newspaper, book and stationers shops in East Anglia.

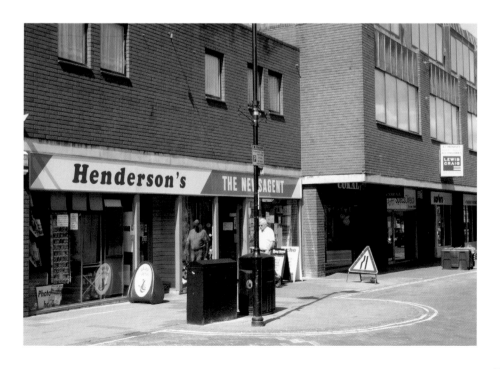

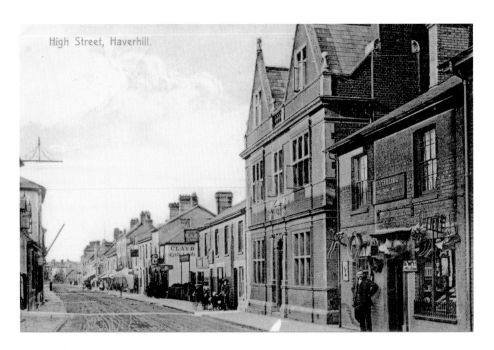

Cambridge House

One of its early occupants was Mr C.F. Freeman, a solicitor and Clerk to the Local Board. As a private house, it had sixteen rooms; later it was used as the Labour Exchange. On the right, Mr Starling, picture frame maker and toy seller, stands proudly outside his establishment. Cambridge House has now disappeared, as have nearly all the buildings from the older photograph. In the Glasswells building, an estate agent's sign hangs where the Woolwich Building Society used to trade.

The Ram

This public house was one of the oldest and most popular in the town, often having a Haverhill person as landlord which helped its cause. Cambridge House is in the hands of its last occupants, the Saffron Walden Building Society. The Ram, as well as most of the buildings in this part of the High Street, was pulled down in the name of progress and to make way for a new concept in town design, Jubilee Walk. Glasswell's store was built on the Ram and Cambridge House sites.

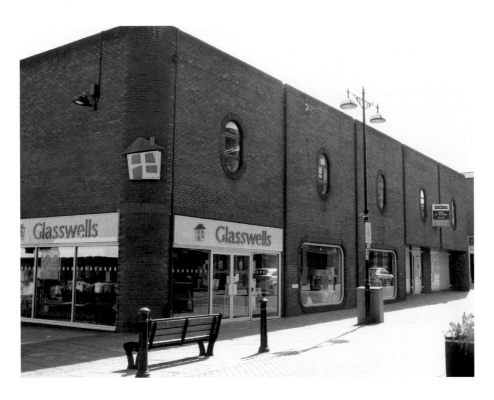

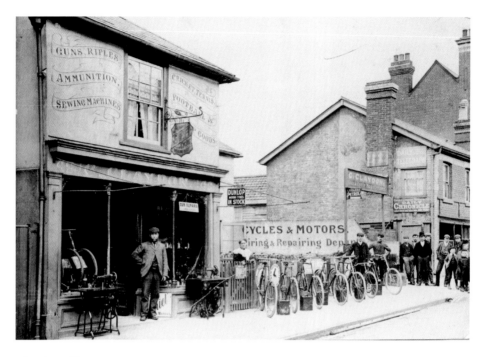

Claydons Shop

Established in 1895 and seen here in 1910, Claydons sold, amongst other items, guns and ammunition, sewing machines, cycles and sports goods. In the square behind the cycles was an establishment called the 'On The Square Library', a private business. Again all has changed with new shops on the site. The Jubilee Walk entrance is where the bicycles were. Down Jubilee Walk, an old tree from one of the gardens of an old High Street house stands as a reminder of the past.

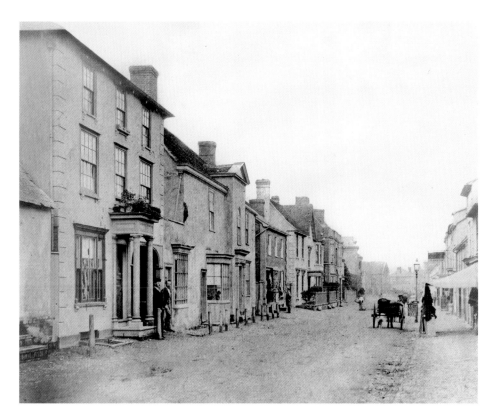

High Street

One of the oldest views of Haverhill. The building on the left with the ornamental porch became part of Withers Garage much later. The house with the outside railings is Helions House in its old form. In 2009 the scene could not be more different, with pedestrianisation seen as the future. The dirty street is replaced with a flower dominated view. Note the CCTV camera on the large building on the left, a sign of modern times.

The White Horse

This establishment started life as a simple beerhouse, and through most of its years, brewed its own beer. The landlord, Albert Dare, stands in the doorway, looking for the first customers of the day. Dare was the town crier and bill poster for Haverhill; he died in 1917. Instead of the old-fashioned public house, there is now Martin's newsagent, again part of a chain of such shops, with the enlarged National Westminster Bank on the right.

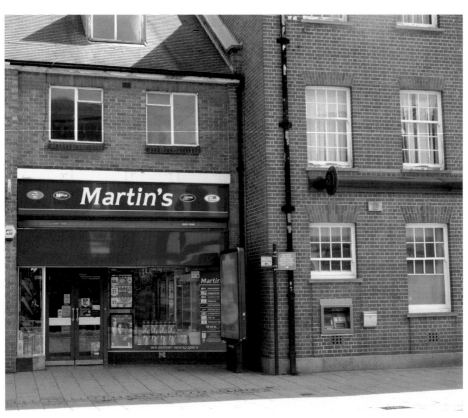

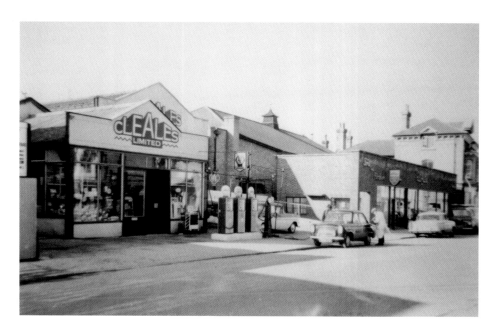

Cleales Garage

Cleales took over from the Central Garage of Mr Turpin in the 1930s. The garage was built in part of the gardens of Chauntry House. To serve a customer, Sammy Clarke has to pull the petrol line across the pavement and over the heads of passing pedestrians. In the modern view, there is no evidence of Cleales Garage having been on this site. It has vanished completely, and been replaced by a parade of modern shops named the Chauntry Centre.

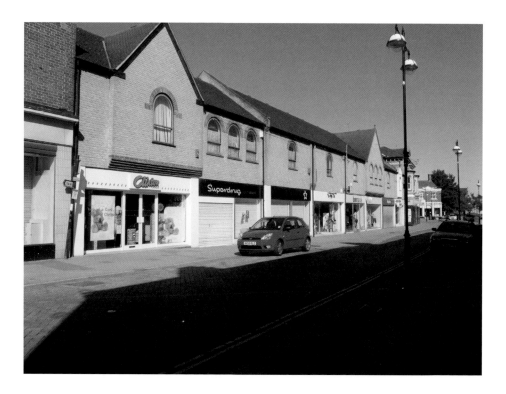

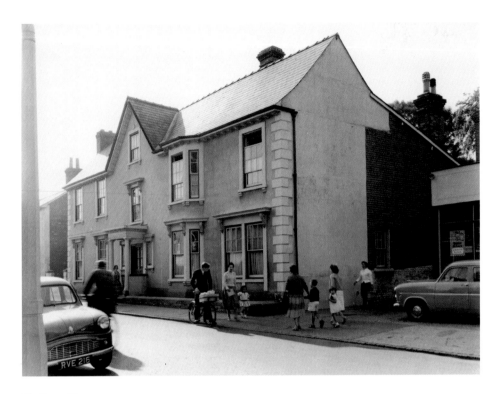

Helions House

Seen here in 1959, Helions was another of the private houses in the High Street which also had spacious gardens to the rear. It continued as a private dwelling until the 1930s when Dr Sunderland moved in and operated his surgery from the house. The site is now occupied by shops. The first business to trade here was Fine Fare; later Woolworths took over the site, closing in 2008. This space is expected to re-open as Iceland Frozen Foods.

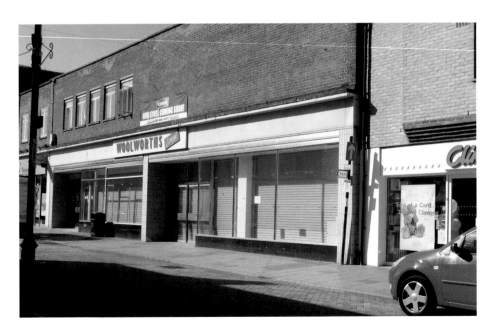

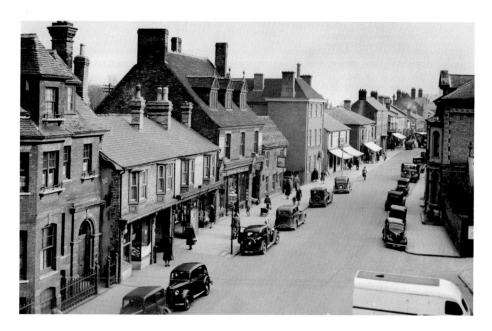

High Street

Pictured in 1958, on the extreme left is Hoveton House, a three-storied building which remained Miss Kate Jarvis' home into the 1960s. Wiffen's greengrocery is next, followed by Simmons fashions, Atterton & Ellis hardware shop, the White Horse and the Westminster Bank. On the right is Chauntry House. The second view is from the second floor of the old Corn Exchange, now an insurance office. The old buildings, except the National Westminster Bank on the left and part of Chauntry House on the right, have been replaced by new shops.

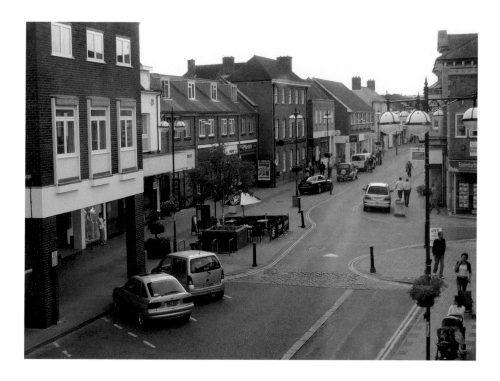

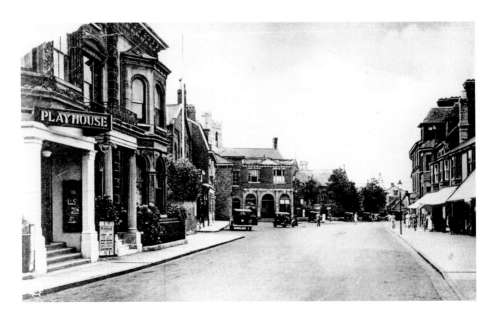

High Street

Chauntry House is now the home of the Playhouse cinema, with the main hall in the former garden. The date is 1936, taken from the names of the films being advertised. In the centre distance is the office of the *Haverhill Echo* in the old Corn Exchange. The Playhouse cinema has disappeared after being a bingo hall for a while, but the top half of Chauntry House retains its character. The ground floor is shops and offices, while the old Corn Exchange is still in the distance.

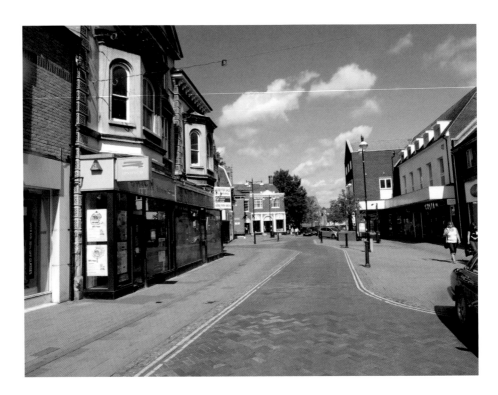

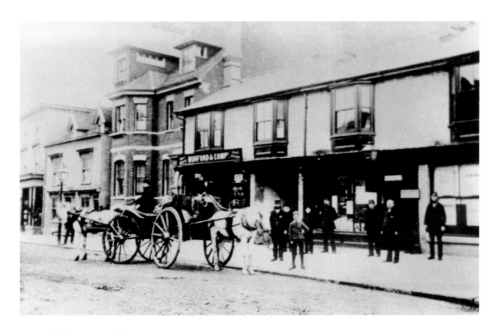

Haverhill Post Office

This is its first site in the town in 1890. On the right is the head postmaster and chemist, Mr Edward Griggs, standing outside his shop with other postal workers and the mail cart. Next door is Munford Fancy Repository, then Hoveton House. This has been replaced with modern shops, including W.H. Smith and Costa, a new coffee bar. The tall building on the right is the approximate location of Hoveton House, pulled down *c.* 1969.

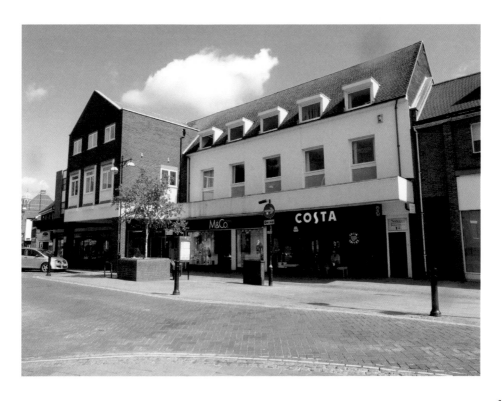

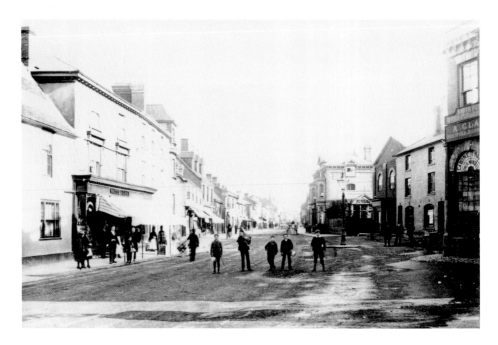

Market Square

Showing how wide the High Street was at this point, and the old market square. On the right is the old Corn Exchange. Beside the Corn Exchange are the Greyhound Hotel and the Market Hill Chapel, which opened in 1839. In the more recent picture, on the right, the Greyhound Hotel has been replaced by Lloyds Bank, and the Chapel has been the premises of Chapman and Sons cycle, television and radio shop since the 1930s.

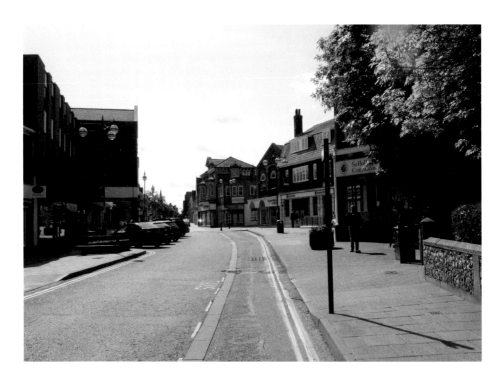

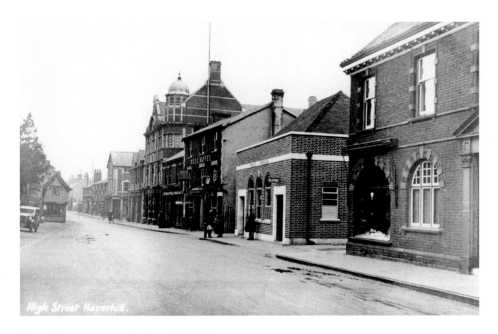

Town Centre around the mid-1930s

On the right is Mr Sharman's chemist shop, next the post office, built in 1933. The right-hand door is a public telephone box. Although the horse has been replaced, there are still signs the animals have left behind in the road. In the modern-day picture. the shop on the right is still a chemists, now a branch of Boots the Chemists. The post office has been rebuilt, and the call box has disappeared. The Bell has also been rebuilt with a patio at the front.

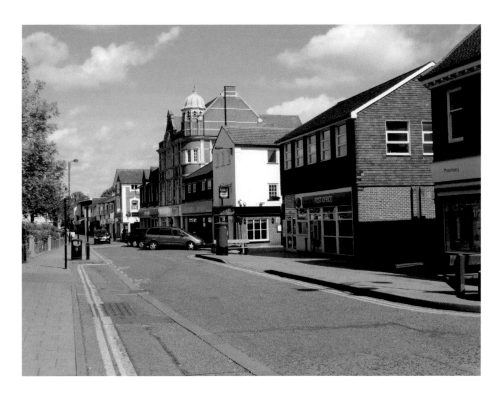

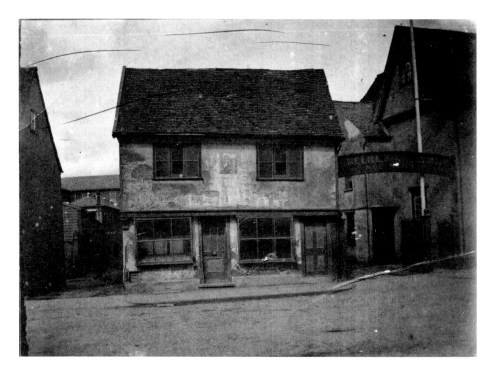

Coffee Tavern

Also known as the Anchor, it is shown here just before it became a temperance establishment. It was opened in an attempt to curb the demon drink in the town. Between this building and the next is Crown Passage, so-named after the Crown Inn. Today, a complete change sees Boots the Chemists occupying the site, although Crown Passage is still seen on the left.

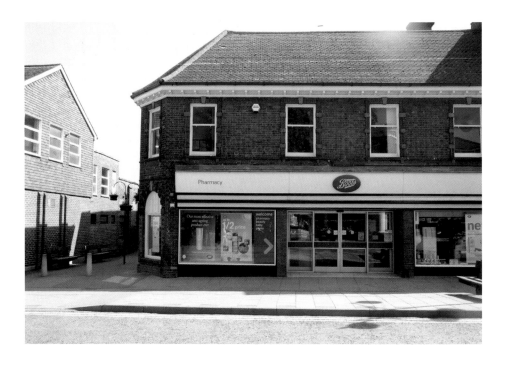

Gurteen's Front Office

This building was originally the home of the Gurteen family who built their small factory at the rear. Production moved across the road to the larger works in 1856. It has been replaced by the town's modern post office, with all the up-to-date services one expects. After being at three different sites in the town, it has now settled in its present position.

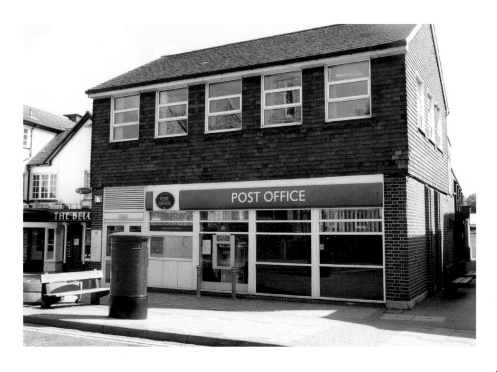

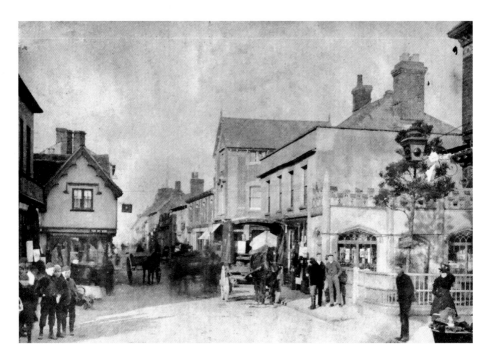

Town Centre

This photo shows how compact the buildings were in the old centre of Haverhill in the 1860s, although there was still room for a small garden. The last house in the High Street appears to be Georgian, but has an extension with a neo-Gothic façade. Jarvis the butchers is on the left. Today, Jarvis the butchers has gone as has the building on the right, which was replaced by the large Co-operative building. It is now occupied by Argos and Peacocks.

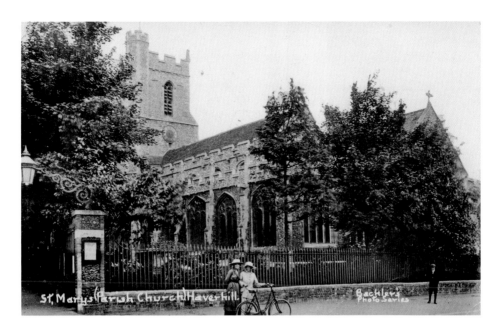

St Mary's Church

This was the second church in Haverhill, which in its early days was known as the Netherchurch, becoming the parish church in 1551. One special monument inside is to John Ward, who helped settle Haverhill, Massachusetts, USA. The small wall at the front has since been demolished, and a higher one built. The churchyard, which had been closed for burials for quite some time, was also levelled and landscaped in 1951.

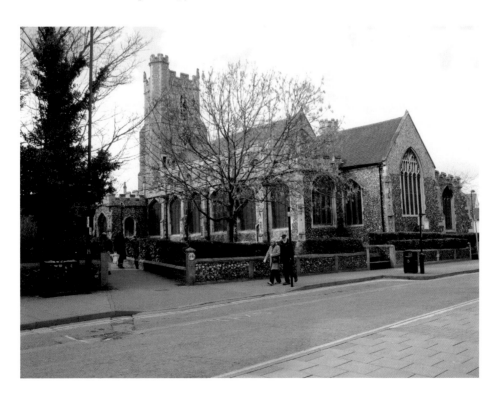

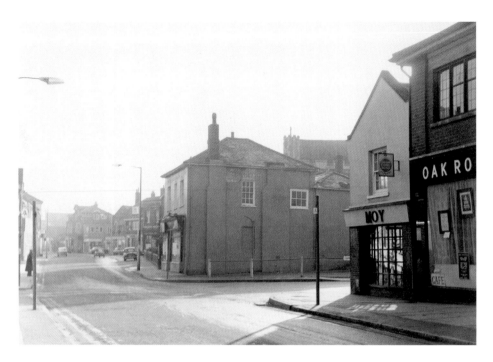

International Stores

This was the last building remaining on the old Peas Hill in the late 1950s. On the corner of Camps Road and Queen Street are Thomas Moy's shop and office. The popular Oak Room café next door was run by Nigel Willis. The International Stores have now been pulled down, allowing a fine view of St Mary's parish church, a backdrop for the new open space. This has also improved the Camps Road High Street corner for traffic. STP computer and stationery stores are now on the corner.

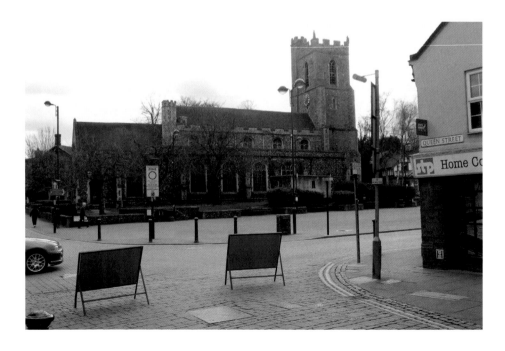

St Mary's Church

The church tower dominates this scene in 1889. At each side of the lower window are two small heads, thought to be those of Andrew de Helion and his son Henry when Lords of the Manor. The brick premises on the left survived into the 1950s, ending its days as a boot and shoe repair shop. The church tower remains the same, but on the right the shop has gone, replaced by the latest public house-cum restaurant, The Drabbet Smock, part of the Wetherspoons countrywide chain.

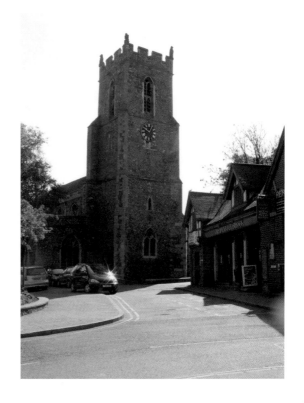

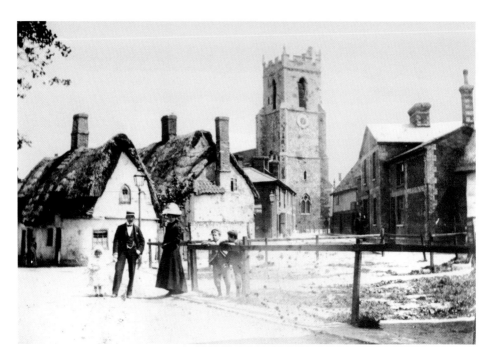

Peas Hill

Old Haverhill in all its glory and its most densely populated was this area close by the parish church. The people, identified as Mr Turpin, a wheelwright, and his family, are standing by the small piece of land with a communal water pump called The Green. Today, the centre of Haverhill has been opened up considerably. Gone are the old houses; the result is the new Market Square, which is still used as the site of the traditional Friday market.

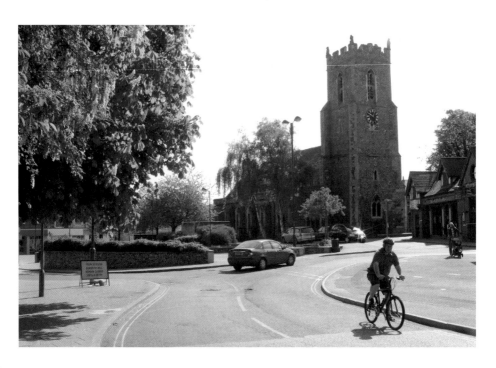

Peas Hill

A closer view showing how the buildings were constructed in various ways. Most of the houses were originally thatched but later tiled. The figure with the trade bicycle at the end building is Jarvis the butcher's delivery lad. In the modern view, gone are the old houses, to create the modern Market Square. The Co-op has moved from their original building to Jubilee Walk. In 1624 there was a mention of a beerhouse called the Lamb on the edge of Peas Hill.

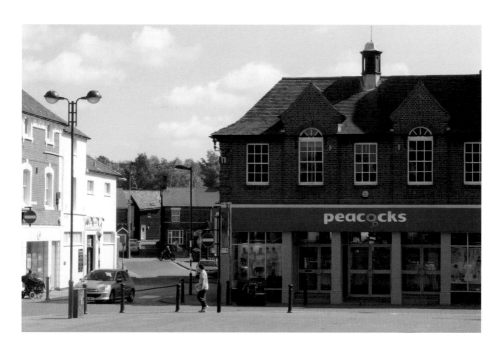

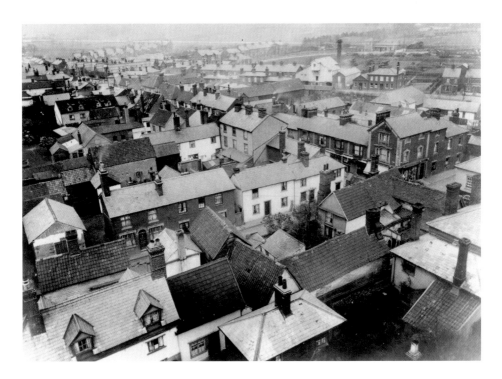

Town Centre

The view from the top of the church tower in the 1920s. Running from left to right at the bottom of the photograph, the buildings on Peas Hill are seen to more advantage. Camps Road and Swan Lane cross the scene, and Queen Street leads up to the top left corner. Since then the cottages on Peas Hill have been demolished, but Queen Street and its offshoots are still crowded. What is most surprising are the many trees still in the town.

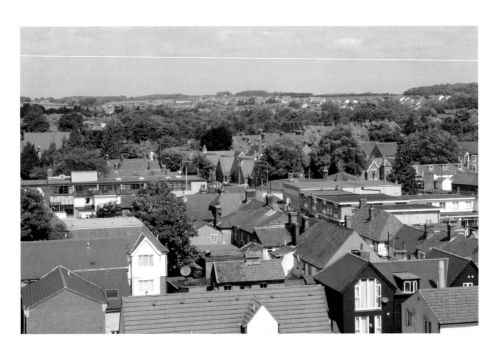

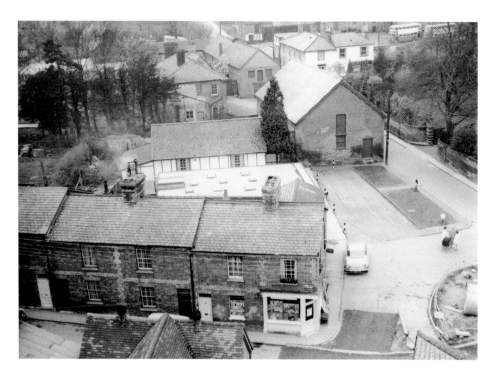

Camps Road

In the foreground is the corner shop in Mill Road. Behind the shop is the doctors' surgery, the gospel hall and Glenbrook House. The Eastern Counties bus garage, which the company took over in 1934, is to the right, opposite the entrance to Burton Cottage. The corner shop is still in place, while the houses in Mill Road have been rendered and painted. The Eastern Counties bus garage has disappeared, as has the gospel hall, and Glenbrook is replaced by the British Telecom building.

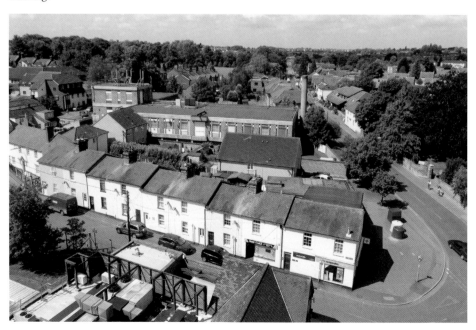

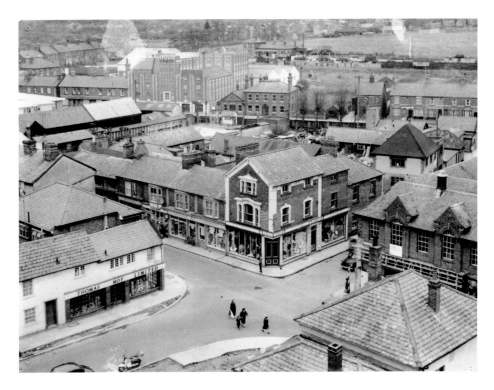

Town Centre

The figures crossing Camps Road, *c.* 1960, mark the former site of Jarvis the butchers, while the International Stores still stands in Peas Hill. Next to the car at the bottom is a 1950s icon, the Lambretta scooter. Swan House still stands on the corner of Swan Lane and Queen Street. The new Tesco store being built on the site of the railway station dominates the background.

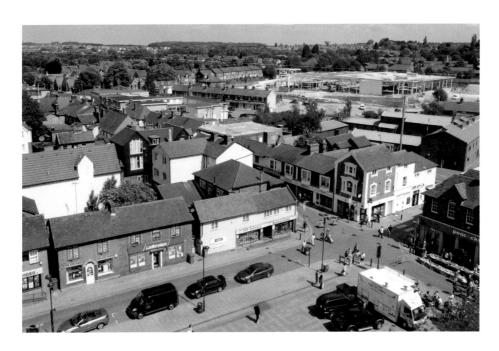

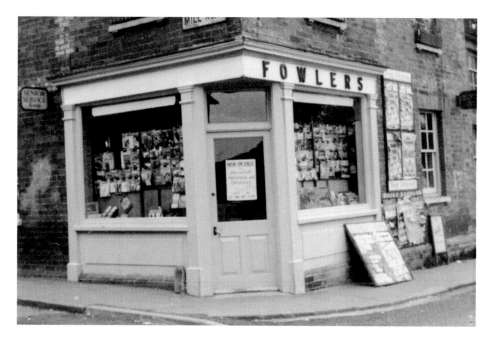

Corner Shop

Mill Road in the 1960s, behind the church and Gurteen's factory buildings. This shows one of the three newspaper and confectioners shops owned by the Fowler brothers, the others being in the High Street and Queen Street. The shop is still trading and has been updated and made more pleasant. It now houses the Co-operative Society pharmacy.

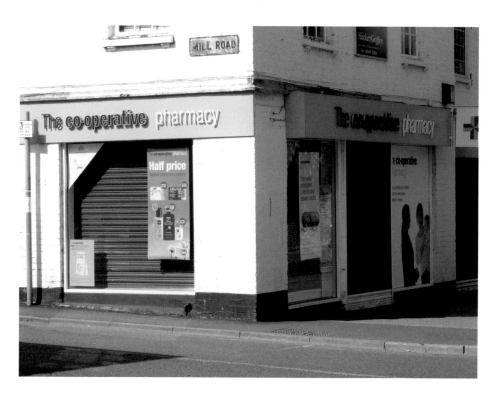

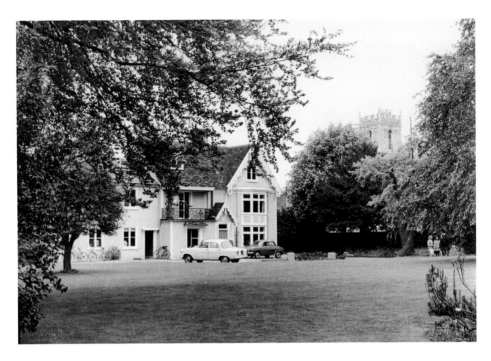

Burton Cottage

This grand old house lay in spacious gardens close to the town centre, surrounded by a high brick wall. The house has a Regency look about it with decorated bargeboards and iron railings on the first-floor balcony. After being a private residence, Burton Cottage became the home for the town's youth centre in 1964, but burnt down in 1987. The new Haverhill Library was built on the site, with the original balcony ironwork placed inside.

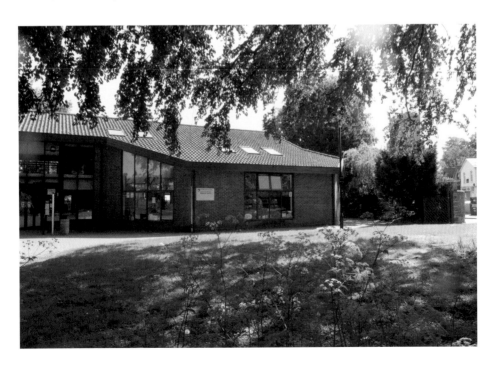

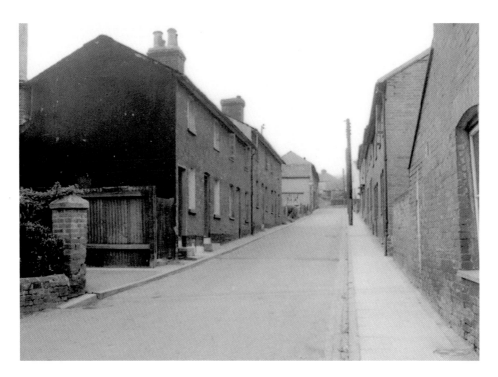

Mill Road

One of the oldest roads in the town, seen from its junction with Chauntry Road. It was part of the old Haverhill area known as Chauntry Croft. There was also the blacksmiths shop of Samson Brown, close to the small yard seen at the bottom left. Today, the houses on the right retain a few of their old features. On the left side, the houses were demolished for some reason which has long been forgotten, and it has become just parking space.

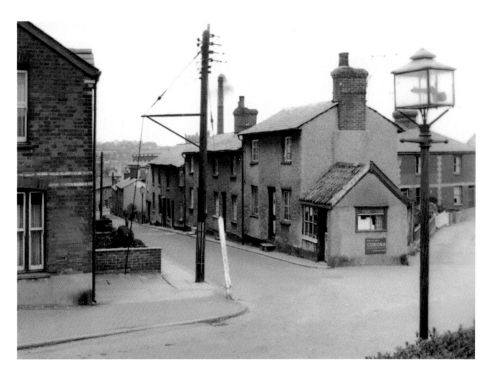

Mill Road

Seen from the opposite end. Taking pride of place at the top of Mill Road is the small sweet shop, run in succession by Miss Hicks and Mrs Poole. Part of Maypole Terrace, a privately-built row of houses, is seen behind the shop. Today, again, the houses on one side have disappeared, leaving a rough area which has become a parking place. Maypole Terrace is still in position while another row of old cottages running parallel with Mill Road, called Chain Row, has also gone.

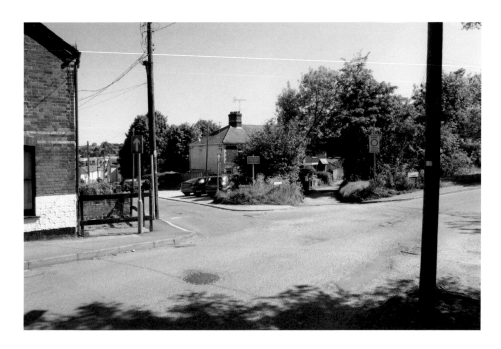

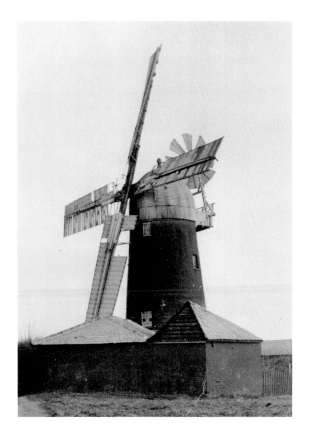

Paskes Windmill

This is a tower mill standing on the ridge of Mill Hill, one of the highest spots in Haverhill. With Mill Field, it is mentioned in many indentures and deeds. It took its name from one of its prominent owners, John Paske, in 1881.
All that remains is the bottom part, now incorporated into the bungalow which was built on the spot. Nearby is a new road named Paske Avenue, after the old mill.

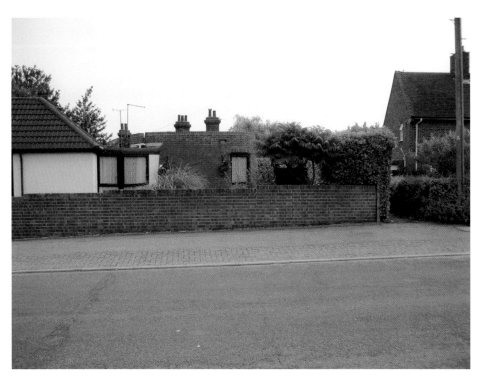

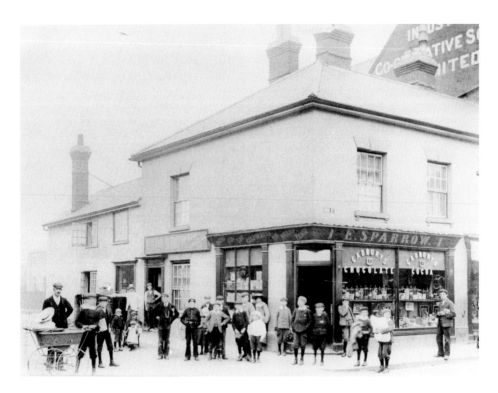

Corner Shop

Number one is at the junction of Swan Lane and the High Street. The group of young people standing around this shop gives a clue to Mrs Sparrow's sweet shop. In the Second World War, the name of the town was painted out of the Co-op sign. In place of the popular corner shop of the past is Peacocks clothing store. To the left is part of the old Co-op premises which was in turn a dance hall and a night club, but both have since closed down.

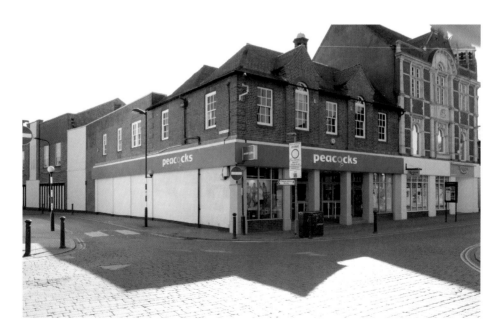

Swan Lane

This building was the home of the Haverhill Urban District Council until the late 1950s. Past the council building are the public toilets and further on, the fire station, built in 1909. The Haverhill council offices moved to a new building in Lower Downs Slade in 1964, and the police station, which had been in Camps Road for just fifteen years, came into Swan Lane.

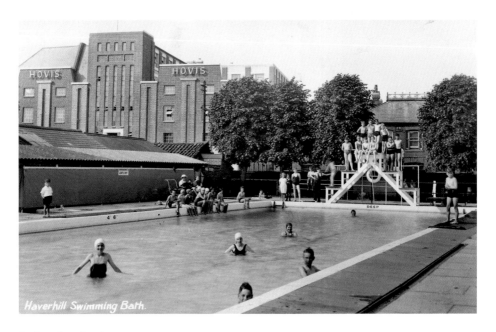

Haverhill Swimming Bath.

Swimming Pool

Shown here in the 1950s, this open-air pool was opened in the Pightle in 1931, after two swimming pools in the town had closed. The large building in the Pightle is Hovis Mill, and behind the crowded diving board is the police station. In the modern-day picture, nothing remains of the outdoor pool. The pool's location is often disputed by older residents of Haverhill; the site is now part of the car park beside the police station in Swan Lane.

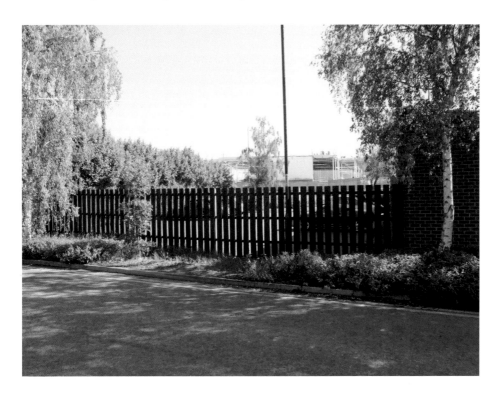

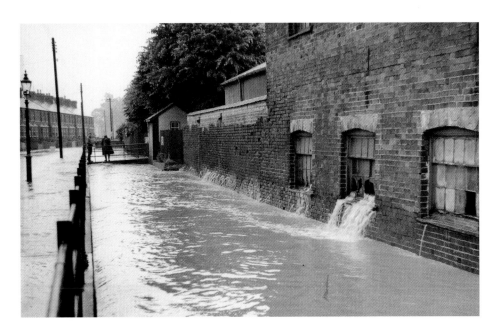

Stour Brook

This small river flows through Haverhill, and is seen here in full flood in 1958, with water streaming out of the old workhouse building, after entering from the flooded Queen Street. All that remains from the older photograph is the old brick wall which was next to the swimming pool. The workhouse buildings have been razed to the ground, and the site is now car parking for the modern Queens Square.

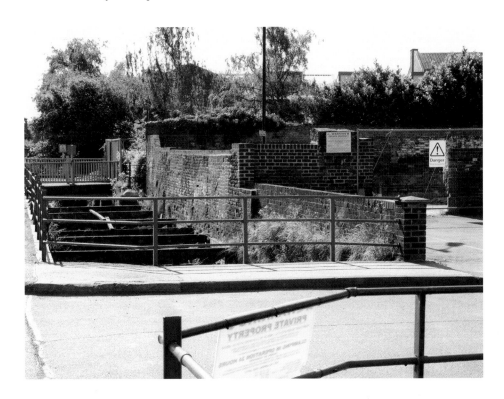

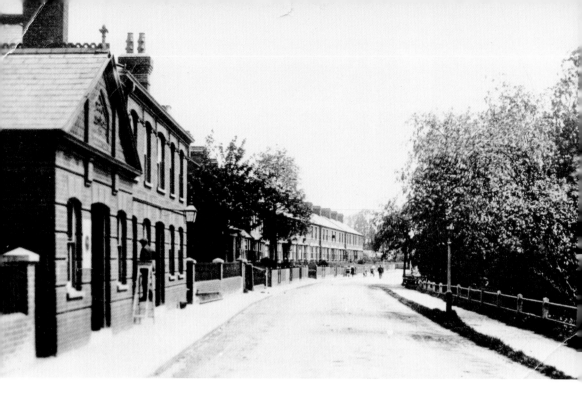

The Pightle

The window cleaner is busy in 1912, at the police station and the courtroom on the left. They were opened in 1886, and the courtroom was often used for meetings. The name Pightle comes from the word for a small field or enclosure. The police station and courthouse have now disappeared to make room for the road to the new superstore. Still in the same place appears to be the lamp post on the right next to Stour Brook.

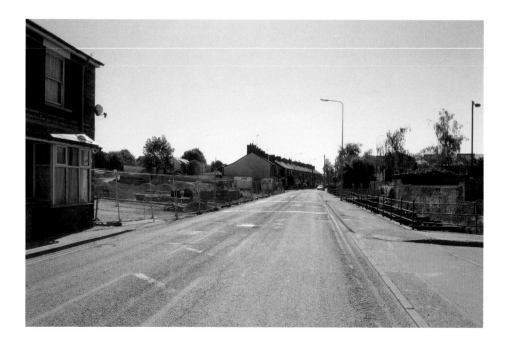

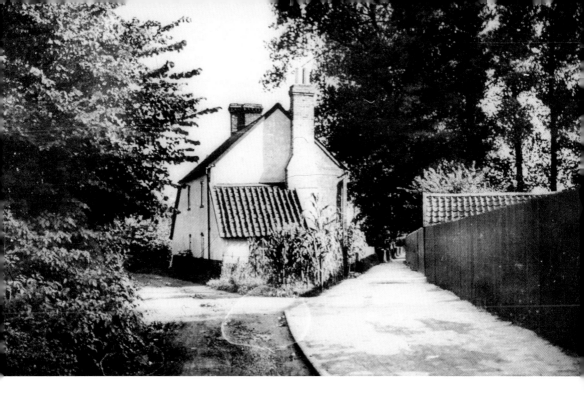

The Meadows

One of the few houses in this pretty area of the town was the house of Mr Richardson. The lane leading off to the left was Fibre Lane, so named because of the waste from the mat factory being disposed along this track. The Meadows are now part of the town's relief road, renamed Ehringshausen Way after Haverhill's twin town in Germany. The site of the Mr Richardson's house is covered by the Kentucky Fried Chicken. Fibre Lane ran approximately across the front of the Leisure Centre.

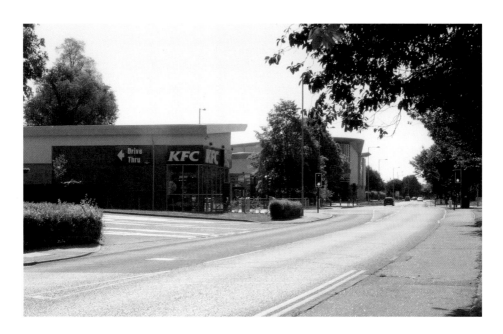

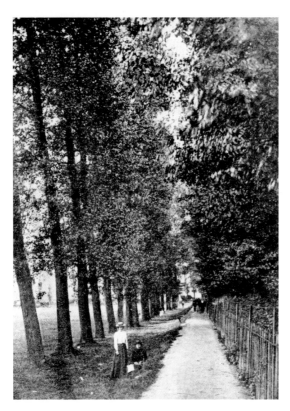

The Meadows

One of the most attractive parts of Haverhill, which extended from Lordscroft Lane to Hamlet Green. On the left is the wide expanse of the Meadows. This area was a favourite walk for families and courting couples. Haverhill's erstwhile green belt has now disappeared under its first relief road, built to take traffic away from the town's narrow streets. The road follows the line of Stour Brook for most of its way. The cricket ground has been on the Meadows since the early twentieth century.

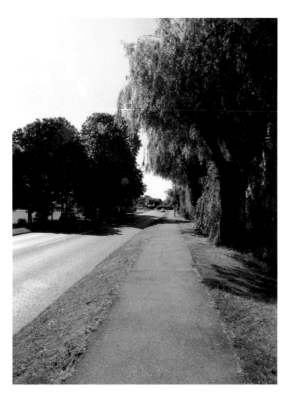

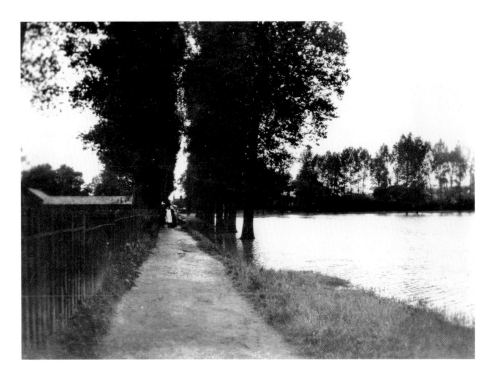

The Meadows

The Meadows shown in the flood of 1903. These low-lying fields were always the first to suffer when the water rose quickly. A track on the right led over the Chalkstone Hills to Kedington. Gone is the quiet beauty of the Meadows today as the road now cuts through the old footpath. In its place is a new cinema complex with additional food outlets. On the left is the exit from Mount Road.

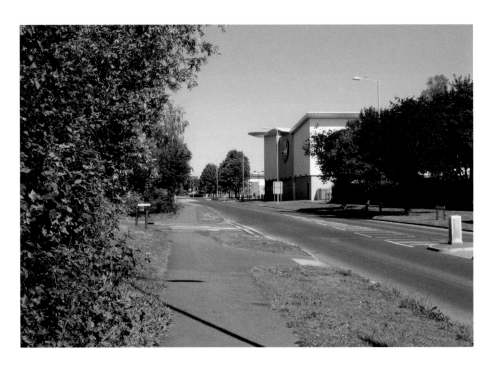

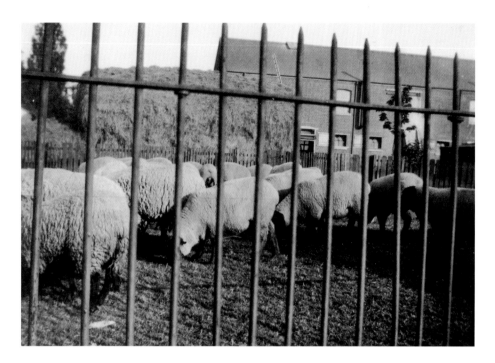

Swan Lane

These sheep are in a small enclosed meadow or yard owned by the Co-op Society in Swan Lane, seen from Swan Lane looking east. The Co-op horses, used for pulling the carts and wagons, were also kept in this area of Swan Lane. The large building in the background was behind the Bell Hotel. This area is now part of a car park opposite the police station. The Co-op bakery was on this spot for many years, having been built in the 1930s.

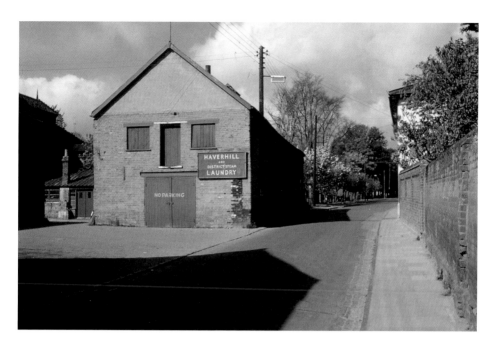

Haverhill Laundry

Situated in Camps Road, the laundry was a well-known part of the town's industrial history for many years. The laundry was built on the site of the old Maltings started by Joseph Boreham. The white house on the right is the Limes, once the home of the Curtis family. There is no sign of the Haverhill laundry in 2009. In its place is a new block of flats, standing opposite Christmas Maltings surgery. The wall which now surrounds the library stands on the right.

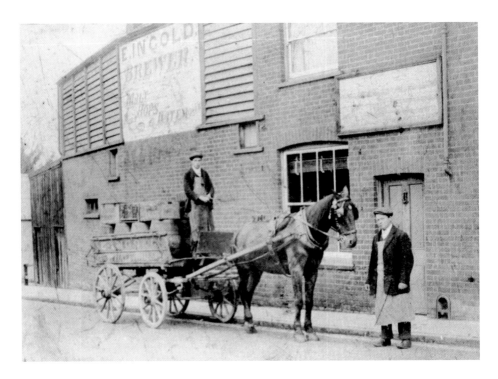

Ingold's Brewery

This was one of the smallest breweries in Haverhill, standing at the end of Chauntry Road near the recreation ground. The delivery wagon is loaded, ready for its daily rounds to pubs in the Haverhill area. Haverhill's first small cinema, the Premier Picture Palace, was built behind the brewery. Today, Ingold's has gone the way of all the town's breweries. This is the car park for the health centre, which is to the left, in Camps Road.

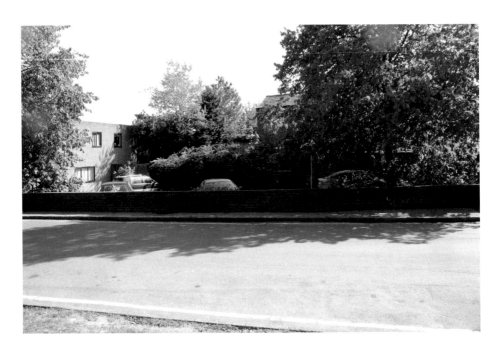

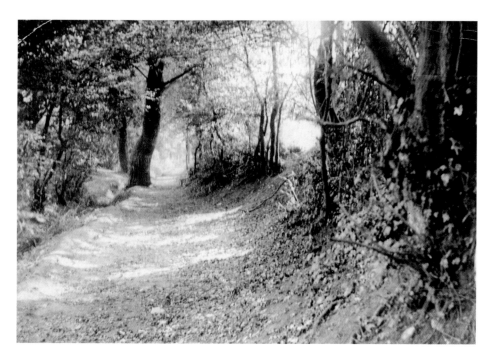

Lovers' Walk

The name given to this secluded part of Camps Road. However, it was not very quiet as there was a stream on the left, coming down from Burton End. The path was by a large meadow which later became part of the Recreation Ground. Lovers' Walk is now part of the Recreation Ground, but still runs between rows of trees. The stream was covered over in about 1910. Aircraft were allowed to park on the Rec when a Church Synod was held in 1931.

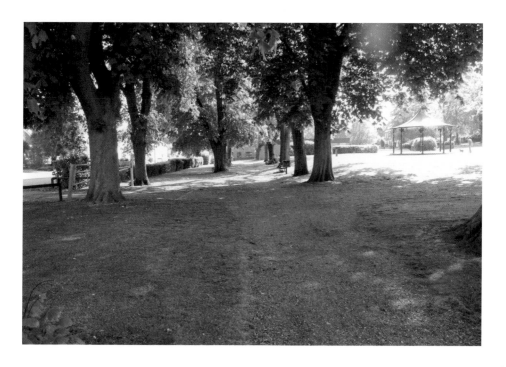

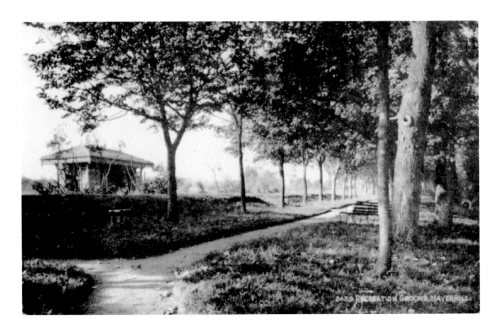

Old Folks' Rest

An interesting structure on the corner of the recreation ground. This quaint building, financed by Mr Conrad Webb, appeared soon after the Rec was opened in 1900. Later a small wooden bandstand, costing £50, was erected towards the top of the new recreation ground. It is still a green corner of Haverhill, but the quaint Old Folks' Rest has been replaced by a modern block which includes toilets and a small shop for the nearby children's play area.

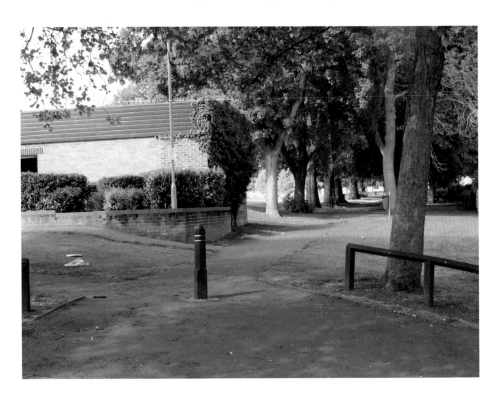

Methodist Chapel

The Methodist congregation was formed in 1854. They built this place of worship in Camps Road in 1874, on a site between the Black Horse public house and Place Farm. The building was enlarged in 1888 as the congregation increased. The ultra-modern Methodist Chapel was opened in 1970, and has plenty of light through its sizeable windows. To the rear a social centre has been added with parking space for churchgoers.

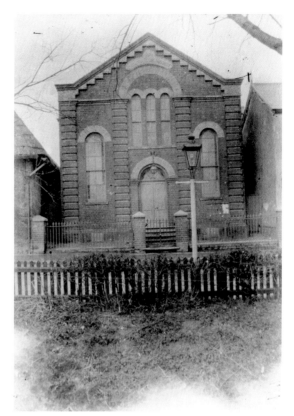

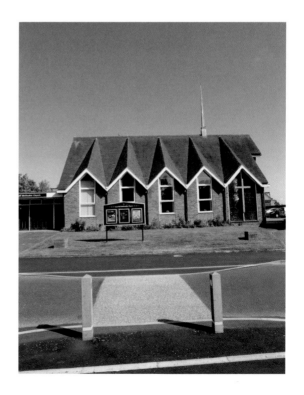

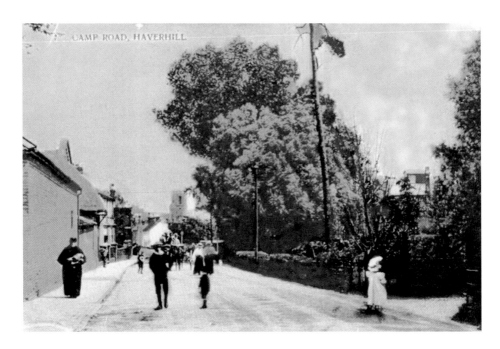

Camps Road

Camps Road *c.* 1900, looking towards the town centre. On the left is a brick building which is part of Place Farm and one of the several thatched houses that remained in Haverhill. Through the trees on the right is the top half of Ingold's Brewery. The old buildings on the left have disappeared except the Black Horse public house. St Mary's church tower is still to be seen, while the trees on the right have been trimmed further back.

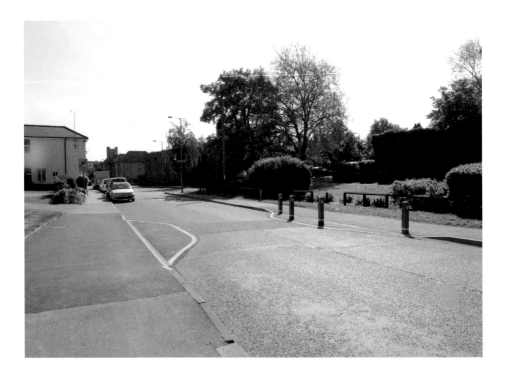

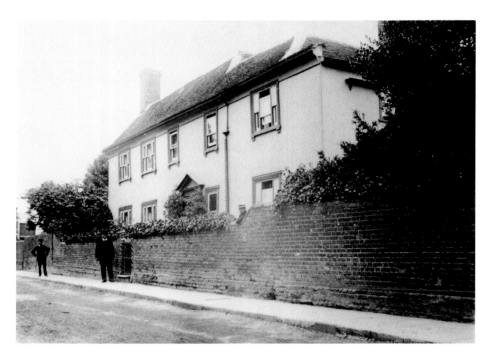

Place Farm

This was the largest of the farms which were actually within the boundaries of Haverhill. The farmhouse was a big building on Camps Road facing the recreation ground. It was mentioned before the fifteenth century, sometimes called Haverhill Place, a corruption of Palace. Although the farm has gone, the name remains in the replacement building, which is Place Court Residential Care Home. In the distance are Vine Cottages, part of old Haverhill.

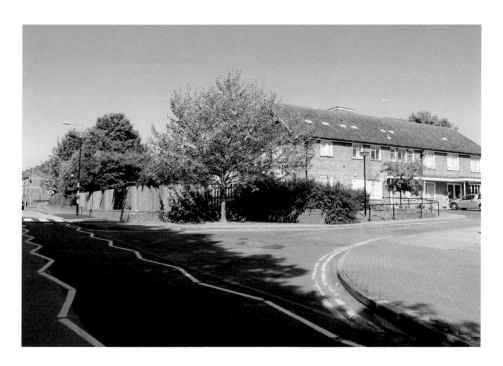

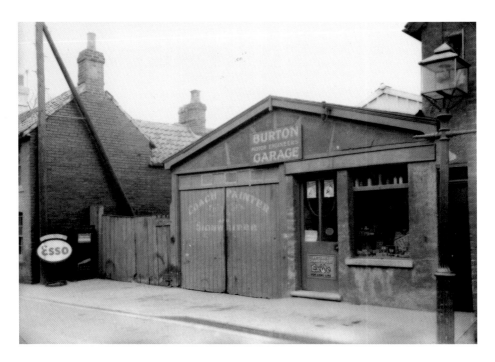

Burton Garage

This was the headquarters of Burton Coaches Bus Company, a private firm started by the Richardson family in 1948. Its office was in Burton End, with the garage in Clements Lane. Most of the company's work was private hire for seaside trips, football clubs, and special outings. Today it presents another completely different view, with the old garage having been re-located, and in its place another old people's residence, run by Havebury Housing Partnership. The new entrance marks the site of the office of Burton Coaches.

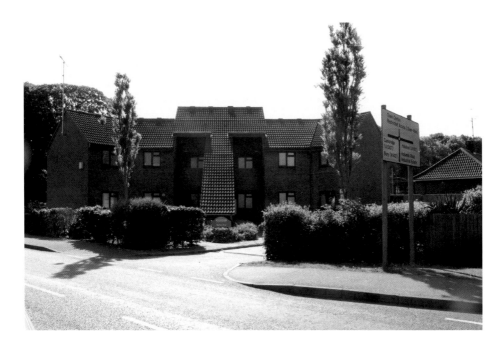

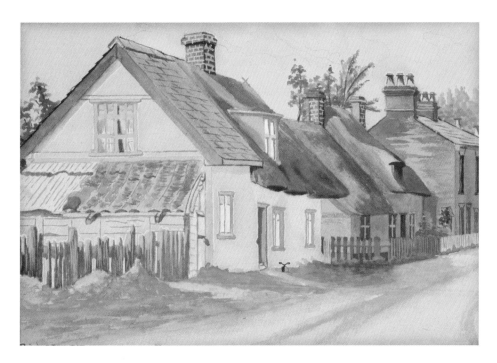

Clements Lane

This painting shows old cottages in Clements Lane. Some survived well into the 1950s. In one of these houses lived the first caretaker of the Rec, Mr Pocock, an elderly townsman who looked and sounded quite soldier-like in speech and gait, and was also tall with a waxed moustache. Today, instead of thatched cottages, there are bungalows, accommodating some of the elderly people of Haverhill. Behind these is the Clements Estate, the first estate built for the London overspill.

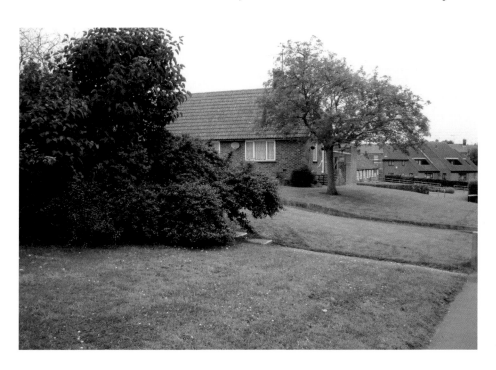

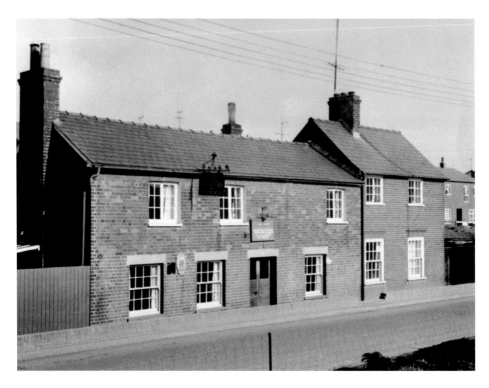

Royal Standard

A popular public house standing in Burton End. Coming into town from the waterworks hill, the Standard was the first public house the village visitors came to, and as a result often did not venture any further. The public house was demolished and re-built on the Parkway Estate in Queensway, but has now disappeared altogether. The old pub stood close to this site.

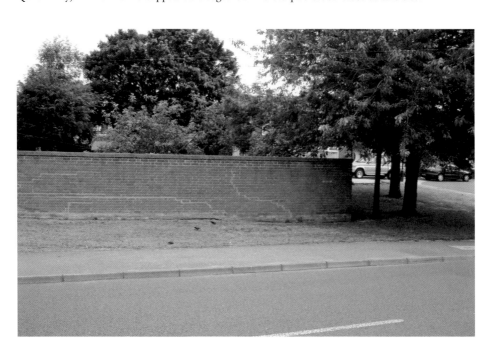

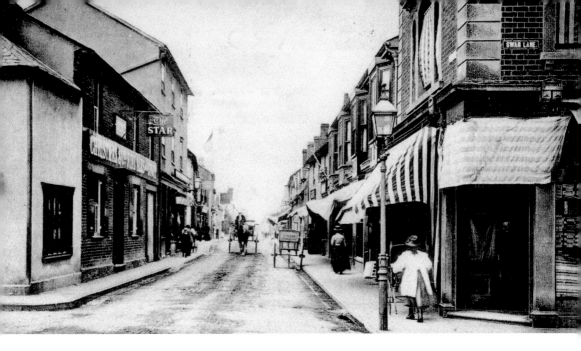

Queen Street

Known through the ages as Bridge Street, and later Bakers Row at one end and Beggars Row towards the Cangle. This postcard shows how narrow the street is. On the left is the Star public house, on the right, Swan House. Today's view shows some of the oldest buildings in the town. After being part of the main A604 road between Cambridge and Colchester until 1960, it is now for pedestrians only during the day.

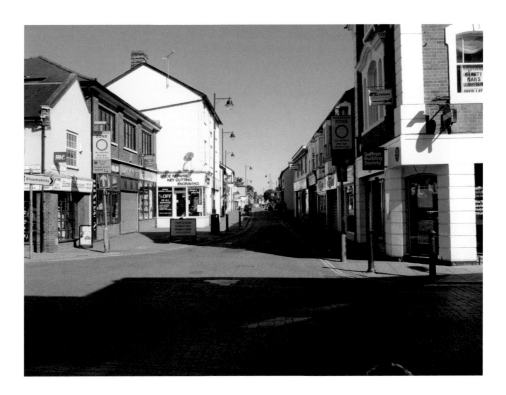

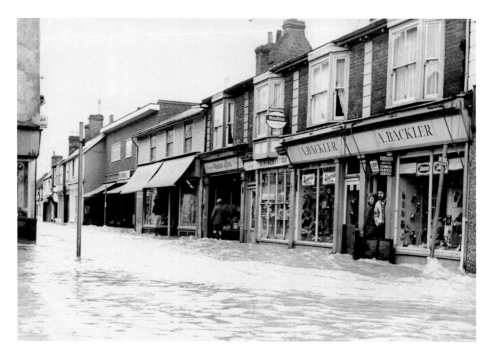

Queen Street.

During the great flood of 1968, with the water flowing down the street as fast as a spring tide at the East Anglian coast. The shopkeepers and their assistants can do nothing but barricade the doorways. The most obvious changes are to the shops, which all have new owners. On the right are Cambridge Evening News, déjàvu, Zeiss Designer Clothes and Morley's. The shop on the left is now an engraving and shoe repair shop.

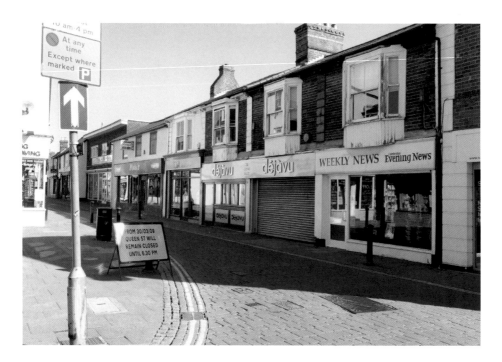

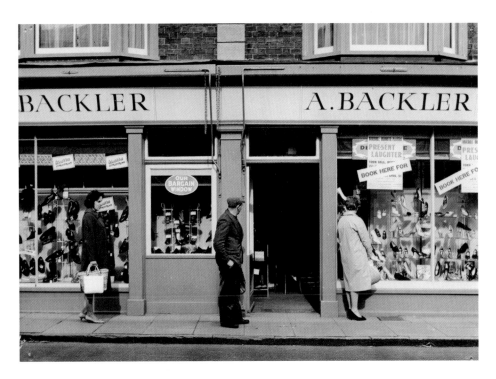

Backler's Shop

This double-fronted shop was one of the last in the town in the hands of a local family. Archie Backler was a well-known figure about Haverhill, and was connected with the Boy Scouts and the West End church. Today, in place of Backler's are déjàvu and the newspaper offices. While the ground floors have altered, the top half of these shops are still the same, with the bow windows and the shapes of the roof identifying their location.

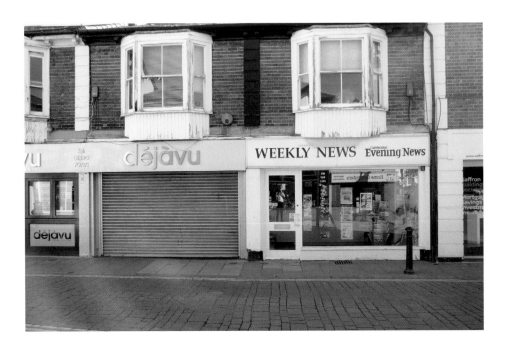

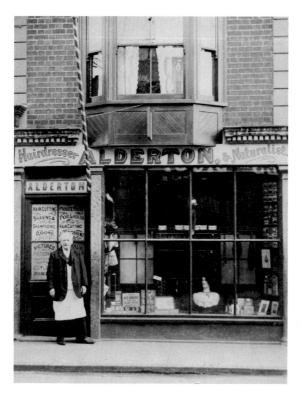

Aldertons Shop

The hairdressers and barbers shop in Queen Street, with Mr Alderton standing at the doorway, advertising the many different services he provided. The family kept this shop for several years. The front room was for gentlemen; ladies went through to the rear. One of the last traditional hairdressers – *"Just a trim, like?"* – Alderton's has made way for reconstructed shop fronts.

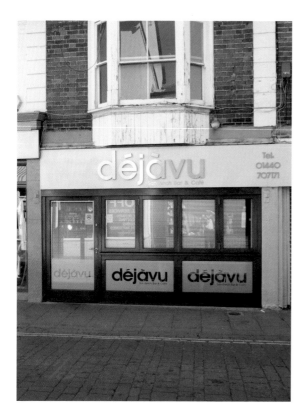

King's Head

This public house stood in Queen Street, only a few yards away from the sister establishment, the Queens Head. Note the prominent sign in the window for ginger beer. This gentleman at the front door is Ernest Horwood, landlord in 1916. The King's Head has made way for a Chinese takeaway. The old public house building can still be recognised by the top two floors of the food shop.

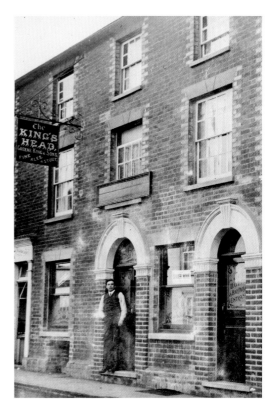

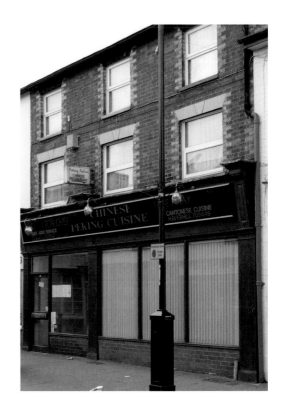

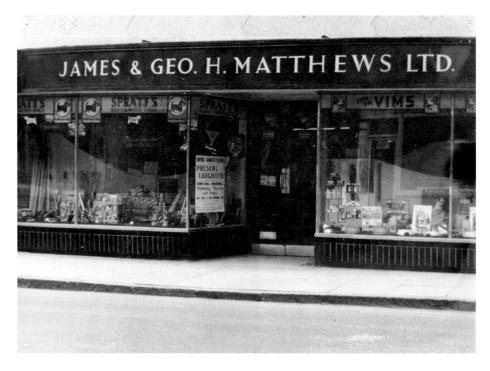

Queen Street

James & George H. Matthews was one shop which stood out from the others. The top of the shop curved outwards from both ends to form a small shelter in the doorway. A daughter of the owners, Joan Matthews, was the voice behind the announcements at the annual Haverhill Gala. This shop is still recognisable as the former Matthews, but it is now the home of two businesses from two different continents.

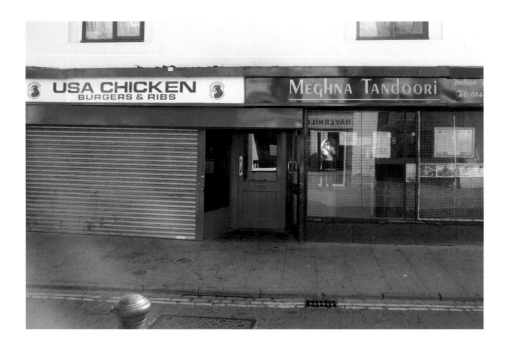

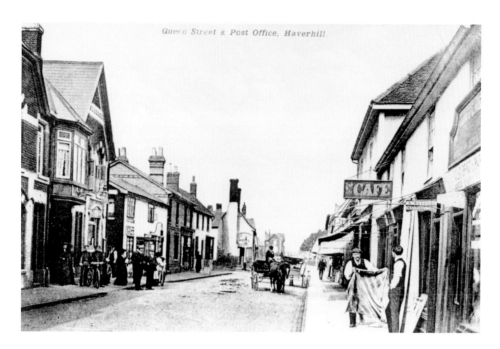

Queen Street

On the left, a group stands outside the post office. The building with tall chimneys at the end of the street is the Temperance Hotel. On the right the canvas blinds are being put up at the coffee rooms of Walter Andrews. The modern view shows that the tops of some buildings have not changed but much has been altered at ground level. The café on the right is now a hairdresser, and the Temperance Hotel has been replaced by council offices.

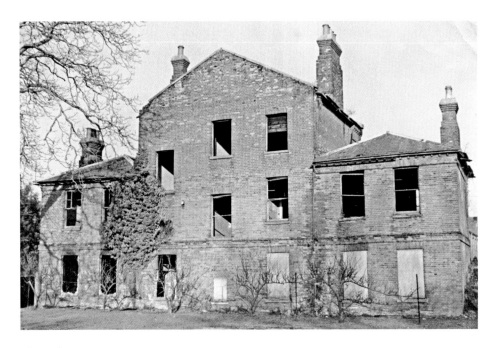

The Infirmary

This stood behind the shops at the west end of Queen Street and was built in 1840, costing £2,200. It had an elaborate gateway in Queen Street. It was intended for the sick, lame, and infirm who could not look after themselves or be in the workhouse. By the mid-1960s the infirmary buildings were looking in a sorry state, and had been for several years. Nobody seemed to want to take these premises on, and so they were demolished. The site is now a car park.

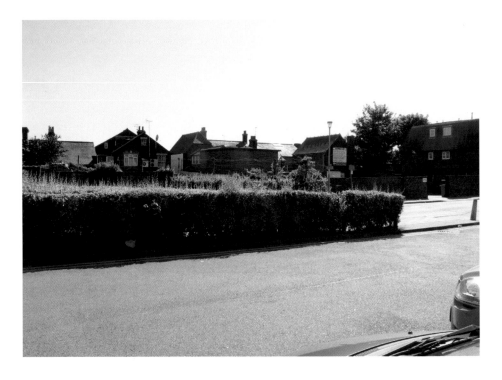

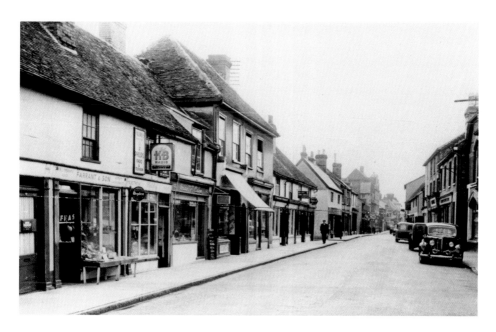

Queen Street

Looking east, around 1950. From the left is Farrants greengrocery, Con Baldrey's radio and TV establishment and two unknown shops. One may have been a second butchers shop owned by Mr Curtis in this area about this time. Today, it is hard to think of this street as being part of the main road through the town. Seen today are the double yellow lines, a satellite TV dish on the building on the right, and a broken window in the shop on the left.

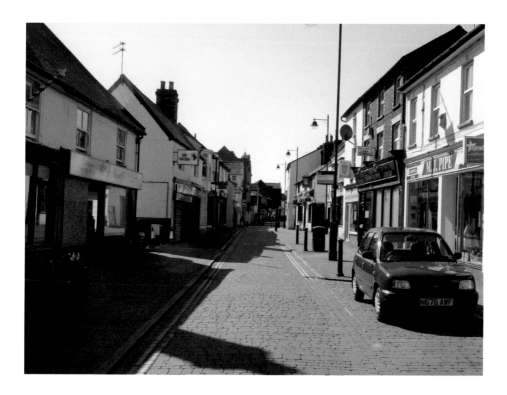

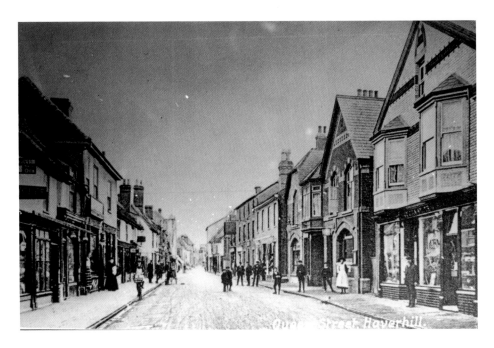

Queen Street

The entrance gateway to the infirmary was on the right. Viewed from the right are the shops of C. Martin, Mrs Webb, S. Nunn, French & Hiners, and the King's Head. A bicycle shop is on the left. The shop on the right is now a Premier convenience store, next door is a hairdressers, one of several in this street. The horse trough originally at the Cangle corner has been re-sited in this street and is barely visible behind the car on the left.

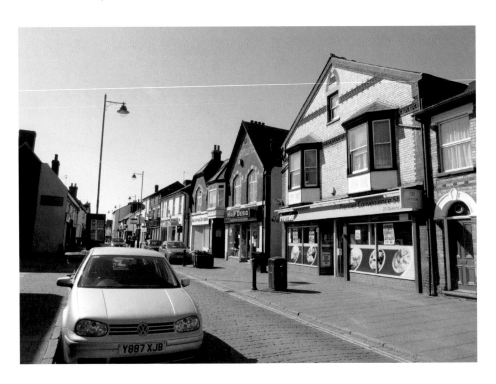

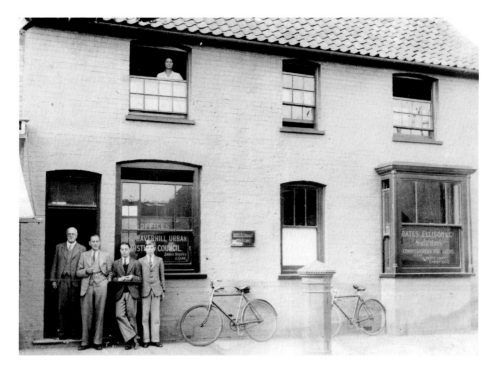

Council Offices

The Haverhill Urban District Council had part of their offices in Lower Downs Slade in 1938. The staff standing outside the main door are, left to right, James Beasley (council clerk), Wilfred Whitfield, Phillip Pavey and Maurice Dilley. At the upstairs window is Marjorie Beasley, daughter of the town clerk. When the urban council moved to a new office block opposite their former premises, solicitors Bates Ellison extended their offices. Now it is a photographic studio and gallery.

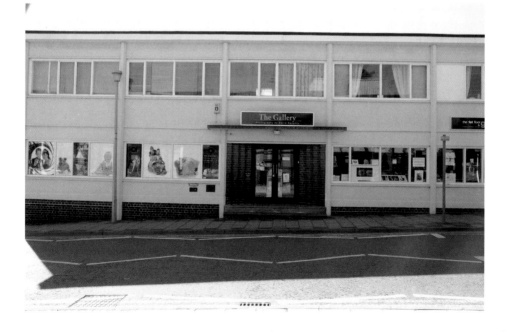

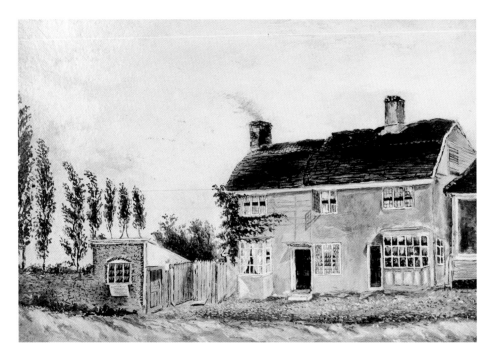

Mr Basham's House

This stood on the corner of Queen Street and the Pightle, the line of which can be gauged by the row of trees on the left. Mr Basham's daughter, Caroline, married Daniel Gurteen Snr. The Woolpack public house now stands on this site. Mr Fuller Chamberlain was in charge until *c.* 1900, also running a horse omnibus from the railway station to other parts of the town. The Woolpack is popular with the younger set.

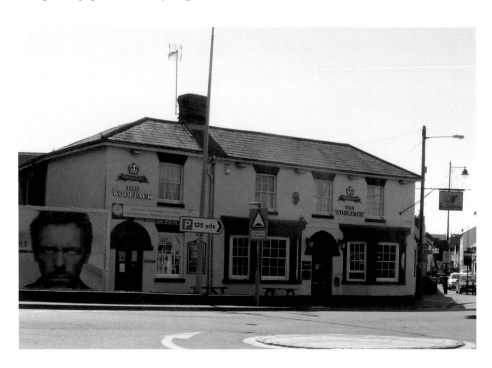

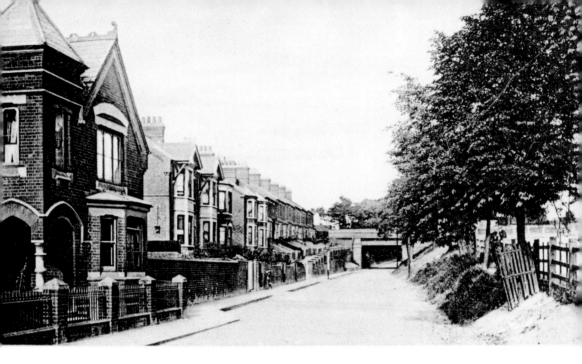

Wratting Road

Originally a narrow muddy track called Mill Road, as it led to Ruffles windmill. On the left is the headmaster's house for the local board school, built in 1876. The terraced houses on the left were mainly occupied by railway workers. Today, Wratting Road is not a pretty sight, with the main entrance to the new Tesco store being laid out a little way up this road. Station Road on the right is more or less blocked off as building work increases.

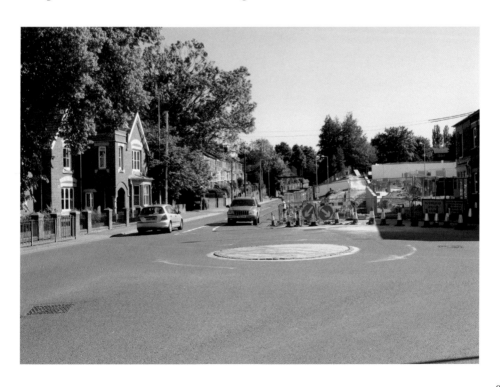

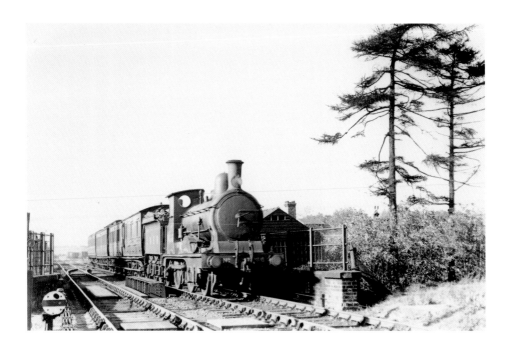

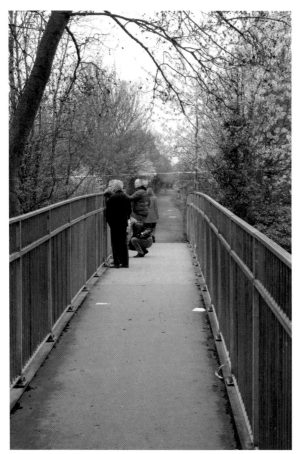

Railway

A train is pulling into Haverhill North Station from Cambridge in the 1950s. It is coming over the bridge in Wratting Road, the line of which is seen from the fir trees on the right. Although the railway closed in 1967, part of the old track forms a footpath through the town and beyond. These people are standing on the footbridge which goes over Wratting Road.

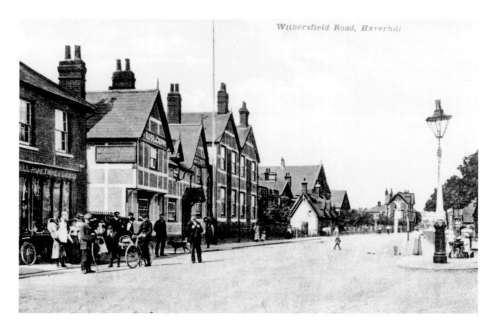

Withersfield Road

This is shown at its junction with Queen Street and Wratting Road. Before being covered over, the river at this spot was crossed by a ford. A group of people are outside the shop of the Haverhill Rope, Twine & Sack Company, the main works being at Burton End. This junction has changed slightly over the years. The rope and twine shop is now a dental centre, and the direction signs are now much larger. The small roundabout has moved slightly and the street lamp has been taken away.

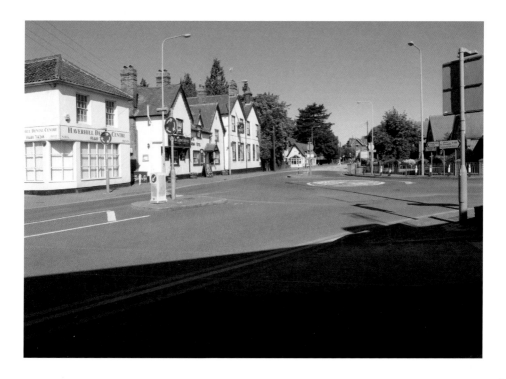

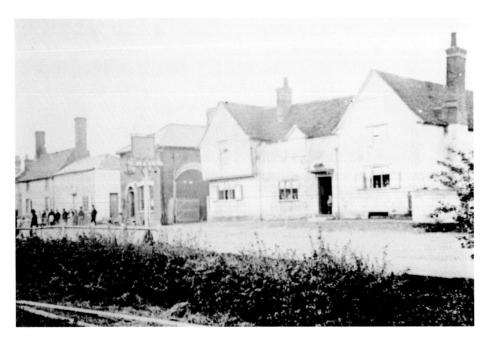

Rose & Crown Hotel

One of the oldest views as seen from the Cangle Meadow, before the local board school was built in 1876. The original Rose & Crown building was probably an H-plan medieval hall house. The present view has to be taken from the grounds of the old Cangle School, formerly the Board School. The Rose and Crown now has two extra sections, and the inn sign is no longer on the opposite side of the road.

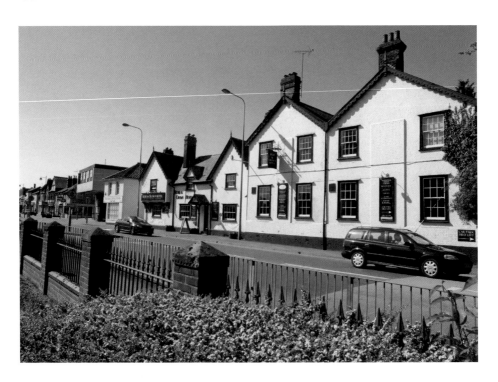

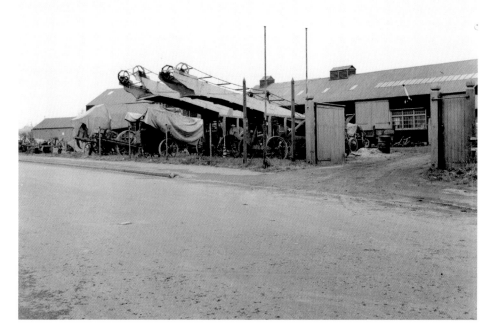

Baldock's Yard

The busy agricultural yard belonging to Baldock's was in Withersfield Road. This firm started out from small premises in Chauntry Road. The large workshops are seen behind the engines and farm machinery which are covered up against the English weather. Gone completely is the agricultural yard, and in its place are more houses for the town. As these are built on the banks of the river in Haverhill, they have been given the collective name of Waters Edge.

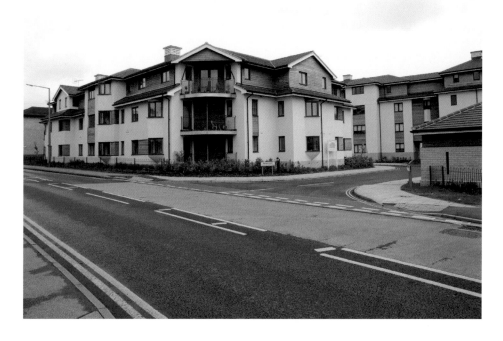

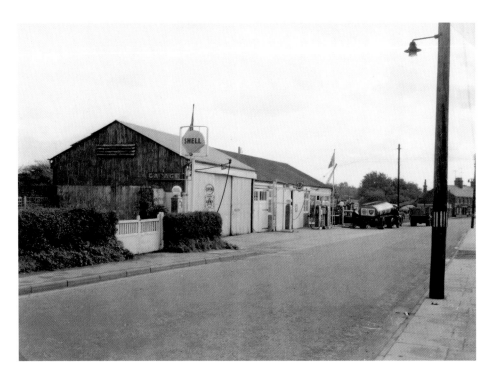

Baldock's Garage

This Haverhill landmark was sited next to Baldock's agricultural yard. It was run by another branch of the large Baldock family, with the owner living opposite the garage. Today, with no sign of Baldock's garage ever having been on this site, this block of flats should have been called Baldocks Close or End. Instead they are blandly called Town End Close.

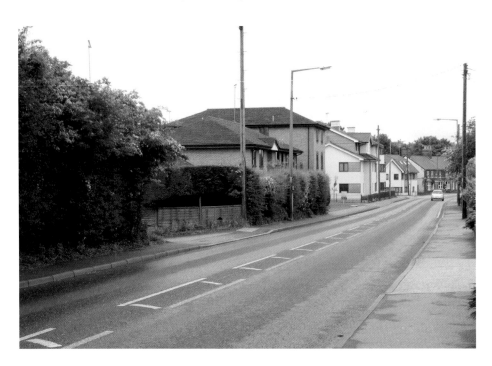